AUTHOR PHOTO

Portraits, 1983 – 2002

AUTHOR PHOTO

Portraits, 1983 – 2002

Marion Ettlinger

FOREWORD BY
RICHARD FORD

SIMON & SCHUSTER

New York London Toronto Sydney Singapore

for

ROBERT EMIL ETTLINGER

FOREWORD

Richard Ford

Marion Ettlinger first took my picture twenty years ago this fall. *Esquire* magazine had given her her first big photo assignment, which was to travel about the United States photographing the author-contributors to the magazine's fiftieth anniversary issue and celebration of itself. There were a lot of writers, almost fifty of us (some very estimable, including Truman Capote, Ken Kesey, Bob Hughes, Elizabeth Hardwick). We lived all over the map, which is where Marion went to take our photographs.

My own residential circumstances at the time were not, for me, atypical. Home was a rented ranch-style house on the outskirts of a town I barely knew, but where my wife had a job, and where I was trying to write a novel. Missoula.

I hadn't had my picture taken much, and never by a tiny, exotic-seeming, dark-eyed, fancy female photographer from a famous magazine, arriving from New York dressed in all-black, with no assistant, no lights, no nothing. A camera and a tripod. I was both nervous and deeply impressed. Impressed with Marion, certainly, who seemed to me a mystery emissary from the fame god; and also with myself, the lucky-duck recipient of that god's gilded attentions. Both of these entwined emotions, a sort of jittery hubris, haunt the picture Marion took of me that pretty fall day—emotions that sit, in my view, not very comfortably on my then smooth-faced visage of semi-young, overly expectant, writerly manhood. I was thirty-nine.

Not much more is memorable from that day in 1983. Not much except Marion, who is very memorable. Small, as I said, dressed like a Vietcong (as if to camouflage her presence); fastidious, patient, expedient behind her tripod. Amiable, but also intense, emanations I felt each time she looked straight at me, just at the moment she took my picture. It only lasted a heartbeat, that sweet intensity—its evidence

a wondrous-seeming and beguiling smile, which seemed to say, "Oh, my, what an interesting face we have here, so good, so surprising, so various, I've never seen one like it, and I believe I've just captured the look that'll make all its qualities evident forever."

It was very nice to have Marion take my picture that day. The fame god, it seemed, was on his game.

In the years since then, I've had my picture taken other times—by famous arty types who only magisterially "stepped into" the setup to effect the shutter snap; by gawky men who shrank behind their black cloths, so you never saw their face—their smile or grimace or mutter; by hotshot photojournalists determined to make me look "interesting" (read "like a moron") and who burned their motordrives like Uzis. And still others so bored with me and my mug, they could as well have been shooting my passport picture. Or my obit shot.

But Marion's over-and-around-the-camera look of notice is by far the most memorable, most fetching of all for being somehow reciprocating. She has referred in interviews to her wish to create an "atmosphere of permission" when she's taking someone's picture. And having shared that atmosphere and liked it, I've always sought to make contact with photographers, eye-to-eye, just at the moment they're performing the semimagical thing they perform—the thing primitive (but not unsophisticated) peoples are said to fear, and just before my actual face begins its time-bound way onward, and the photograph commences its own timeless one.

What is this moment of connection I seek? What Marion calls *permission*? Probably it comprises a lot of things. Surrender. Defiance—the sensation primitive people can't quite master. It's acknowledgment of the queasily personal and unnatural experience of being (along with the film) exposed by another human being. It's nostalgia. It's acceptance. It's vain hope. And most assuredly it's an attempt to strike an intimacy with the photographer—and the camera—which will stamp itself on the picture and ultimately overpower it. What I've always thought, when Marion Ettlinger has taken my picture through these succeeding twenty years, is that *her* face behind the camera registers this entire nuanced exchange of permissions, and confirms that what it seeks is sympathy. The pictures in this book, of course, say I'm right.

Anyone, I think, would agree that author photos constitute a unique sub-species of the photographer's art. Portrait-*like*, they are not exactly portraits, since the opinions they express are as much the ones approved by the subjects as those

approved by the photographer. Indeed, they are collusive, not so much studies as advertisements, averrals that the pictured author of the book you hold in your hand (and who's schoolmarmish enough to resist peeking at the author before reading the book?) is a person handsome, interesting, dramatic, weird, friendly, mysterious, possibly even forbidding enough to have written something you simply won't be able to put down. An author photo is part of a book's *package*, a part of any book we *can*, it's hoped, know by its cover. And in making such a photograph, the photographer at the very least lends aspects of her or his independence and proprietary authority to a separate, contestably higher authority—the author, the publisher, the market. This, I suppose, could be artistically problematic, though only if the essential transaction weren't understood and acknowledged, as it is, say, in fashion photography, or more sublimely in high-school yearbook pix, where the artistic gesture has several components to its complex address. And, of course, if the photographs themselves were not as distinctive as Marion Ettlinger's are.

I think I can always recognize a Marion Ettlinger photograph, read its signature, even downsized to a little porthole window on the back of a paperback, which the author peers through and says, "Hi." Ettlinger's subjects *look* incandescent (some darkroom alchemy I'm not much interested in). Almost always, they gaze at us, unsmiling, and never completely disregard the viewer. Almost always, faces are posed—dramatized by their expressions (nothing at ease or informal), by the photograph's high-finish black-and-white particularity (much texture, facial lines, cheekbones, veins, arm hair); and by light (natural, but tending toward the umbral, from which faces—especially eyes—blaze out, sometimes gravely.) Some photographs feature self-conscious compositioning—props, interesting out-of-studio locales, animal companions: Jeffery Eugenides in the subway, Stewart O'Nan in a diner, James Ellroy standing beside his look-alike bull terrier, Bob Hughes with an apparently still-living, but not well-tonsured, parrot on arm.

But stagings aside, most of Ettlinger's photographs feature a confronting sensation of personal nearness to their subjects, nearness which is not so much intimate or interpretive or situating as privileged and admiring. The author-subject *is* the picture. And what's most interesting or pretty or provocative about each photograph is not what the subject does for a living (they're all writers), but how the subject *looks*, or at least how he or she looks to Marion Ettlinger—or better yet: how the subject looks in her hands. In this way the writer is abstracted from the writing, and the presumption is that everyone's the better for it.

Pictures lie all the time, Avedon has said—a truth which must be balanced against the fact that they also never lie. Away from my mirror, I know how I look; a good picture of me will show it. A bad picture, though—one I tear up and burn—confronts me with someone I don't want to get cozy with. Both, alas, are Richard.

Marion Ettlinger has tried over these years to make *good* pictures of her subjects. Writers, she's told me once, *house* drama (some clearly more than others). And, trusting her gaze to locate upon writers' faces qualities that interest her—terrains, structures, humors, uniquenesses, even winning homeliness—her photographer's vocation has been to enact this drama and make it virtually permanent. If a photograph could be imagined as a moment, Ettlinger seeks to create what she calls iconic moments, when her subjects are most, at least photographically speaking, present and uniquely themselves.

So, when I look at a Marion Ettlinger photograph taken of someone I know well—my great teacher Stanley Elkin, my friends Edmund White, Elizabeth Rosner, Francisco Goldman—I always see a face, a look, an expression, a mood, a temper—a presence—I'd believed only I knew but, with the photograph in front of me, I realize I must surrender to the rest of the world. It's permission I grant.

I could say more. I could always say more. That's my job. But this is enough. You'll look at these marvelous photographs again and again, I think. They compose an unusual and distinct and intense part of the contemporary literary culture. Close up to these women and men, you will think things about them you hadn't thought before, and look more closely. You might even think about a book you read once. Though, away from the covers of books, Marion Ettlinger's work provokes us, as you'll see, as completely achieved photography, inasmuch as there is something purely frank and unwitholding about these pictures' photographic beauty, frankness we may like, even occasionally not like, but which will make us, after a while, think again about ourselves.

AUTHOR PHOTO

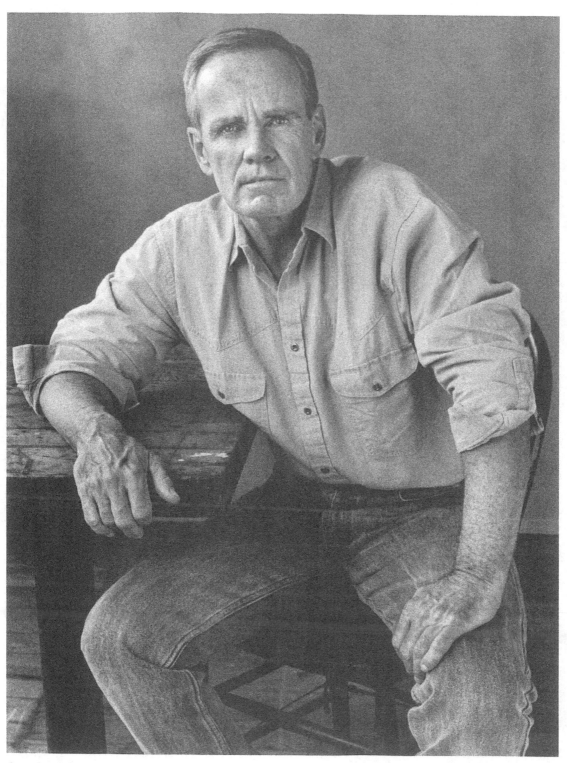

Cormac McCarthy, *New York City*, 1991

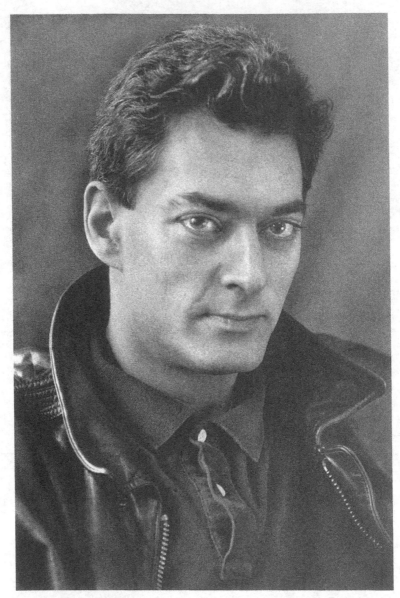

Paul Auster, *Brooklyn, New York*, 1990

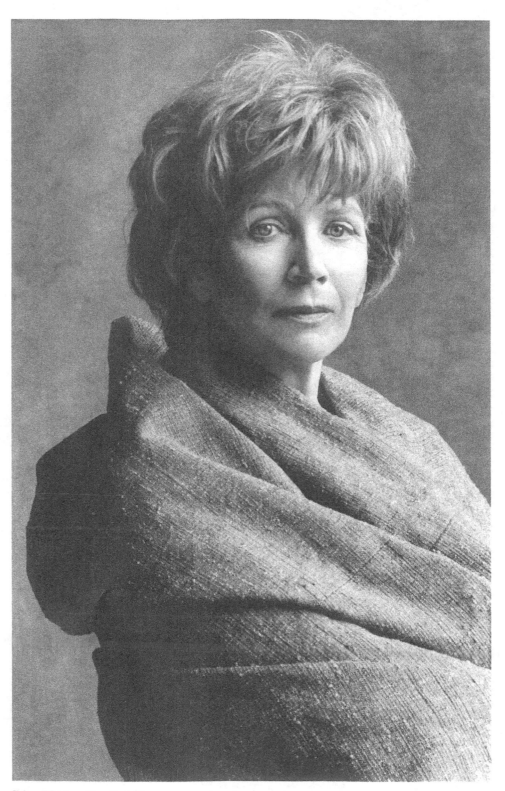

Edna O'Brien, *New York City*, 2001

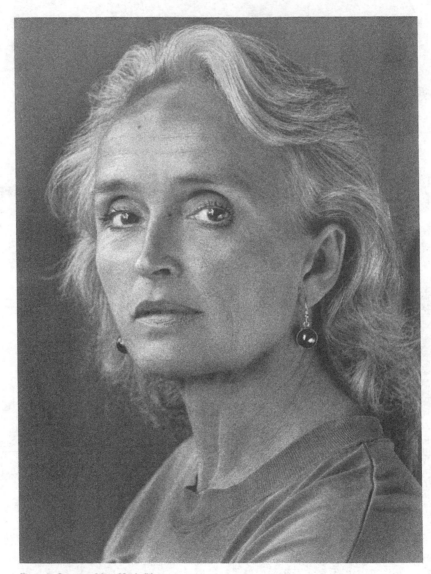

Beverly Lowry, *New York City*, 1991

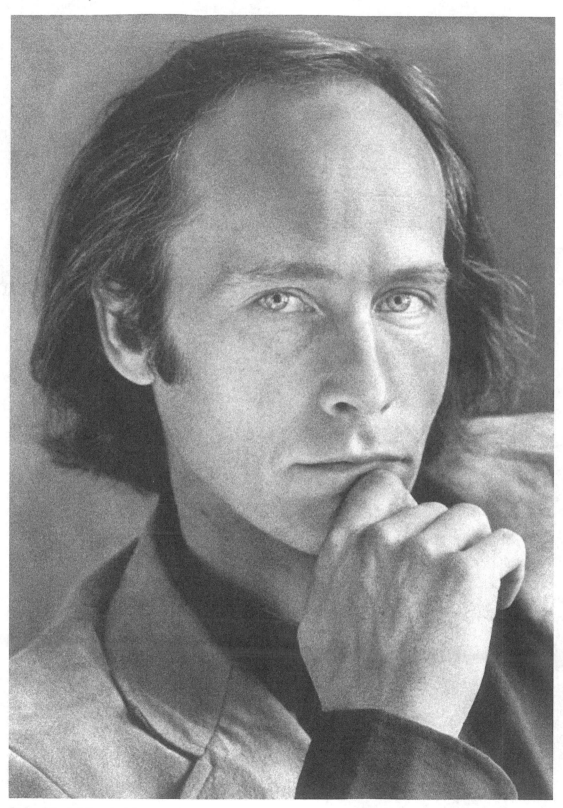

Richard Ford, *Missoula, Montana,* 1983

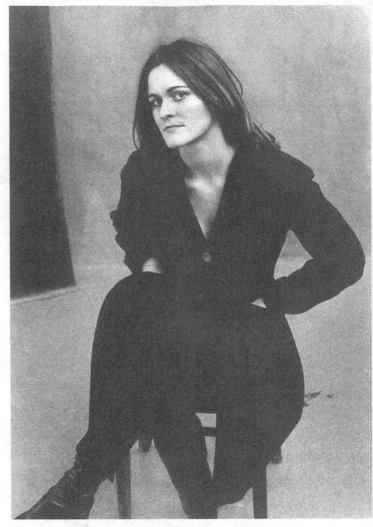

Bliss Broyard, *New York City*, 1998

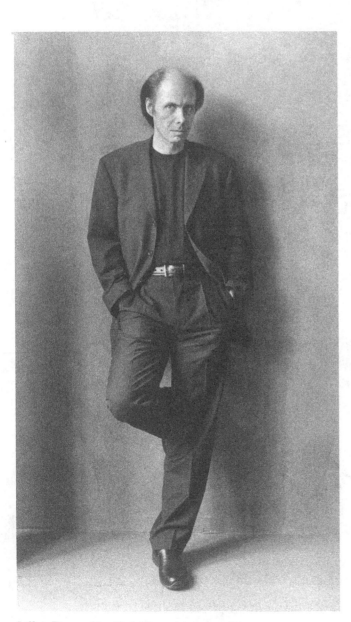

Jeffery Deaver, *New York City*, 2000

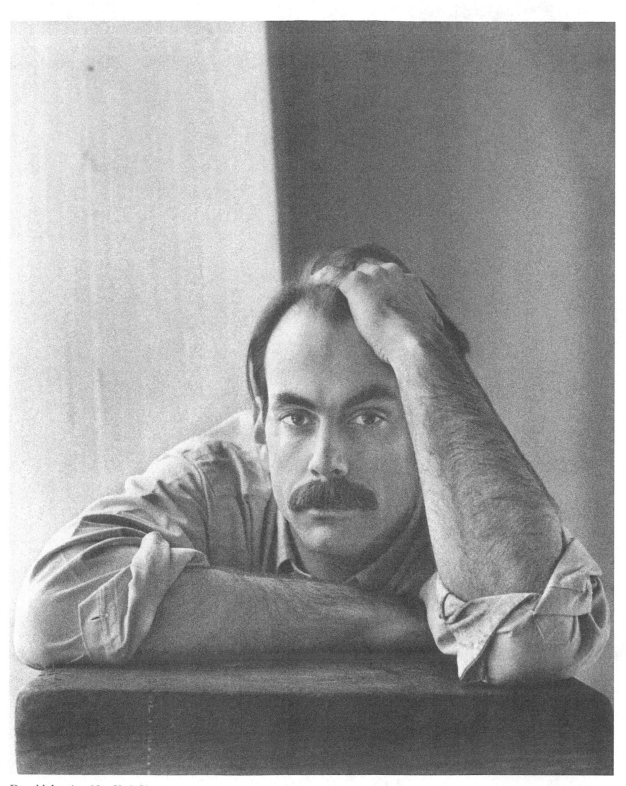

Donald Antrim, *New York City*, 1993

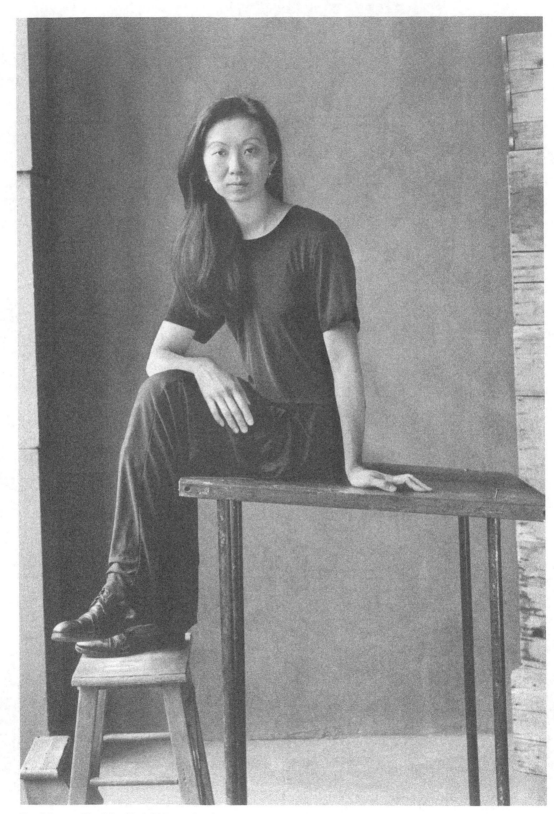

Fae Myenne Ng, *New York City,* 1996

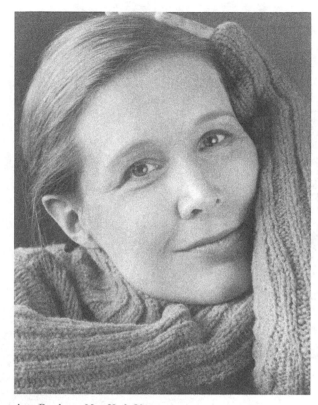

Ann Patchett, *New York City*, 2001

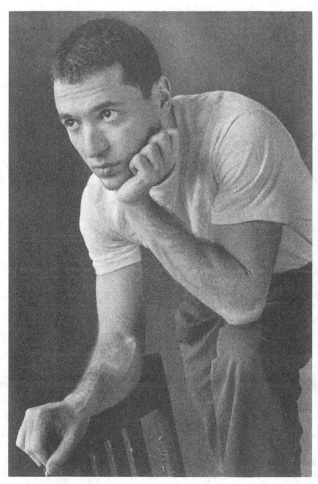

Paul Hond, *New York City*, 1997

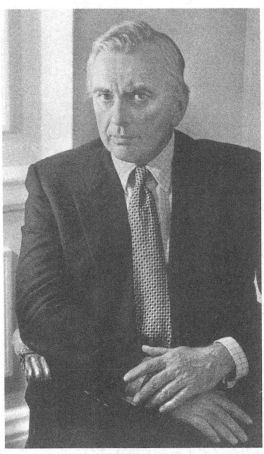

Gore Vidal, *Plaza Hotel, New York City*, 1983

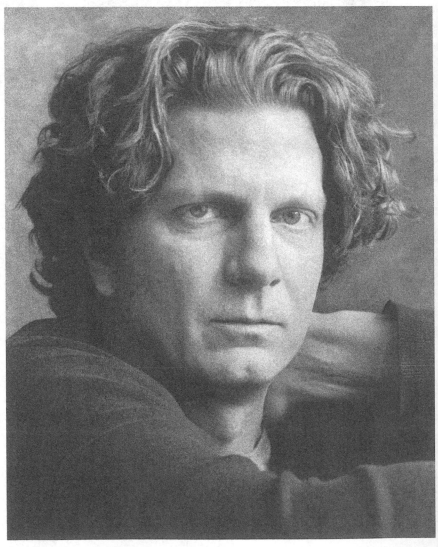

Thad Ziolkowski, *New York City*, 2001

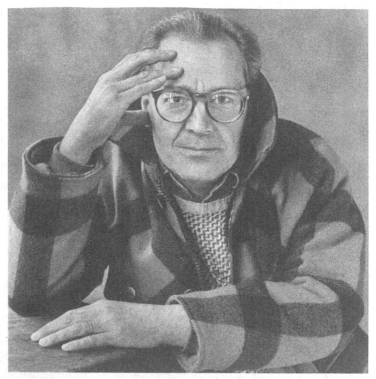

Craig Nova, *New York City,* 1991

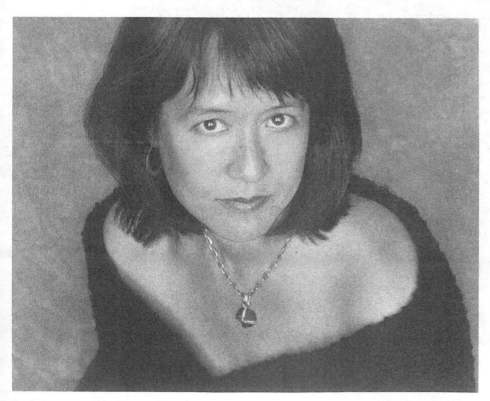

Ruth Ozeki, *New York City,* 1997

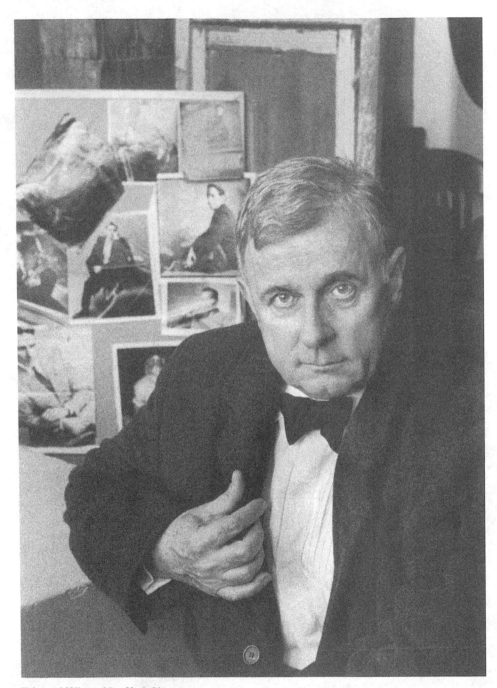

Edmund White, *New York City*, 2000

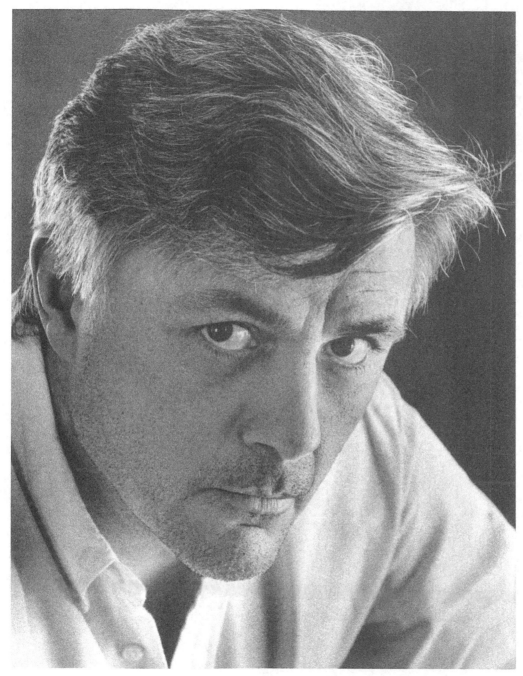

John Irving, *Grafton, Vermont*, 1988

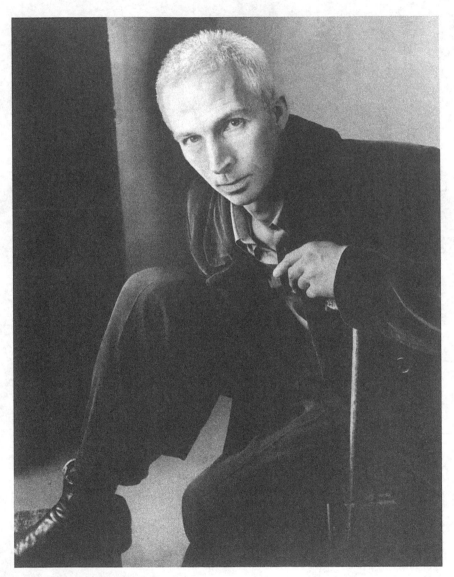

Rupert Thomson, *New York City*, 2001

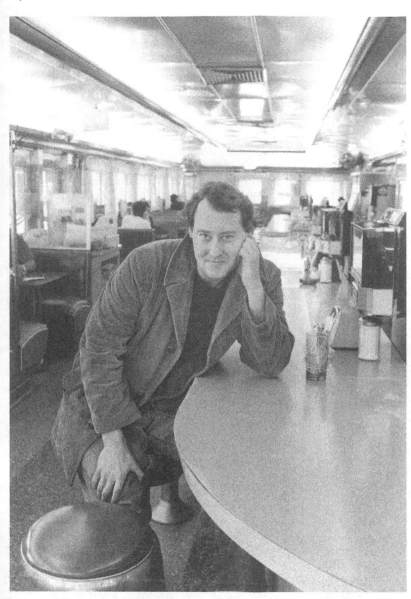

Stewart O'Nan, *Olympia Diner, Newington, Connecticut*, 1996

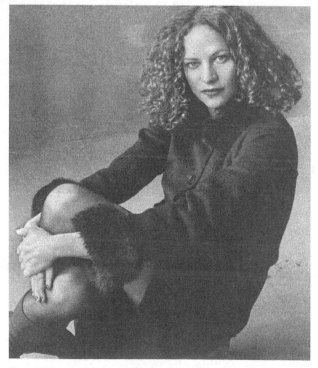

Katie Roiphe, *New York City*, 1998

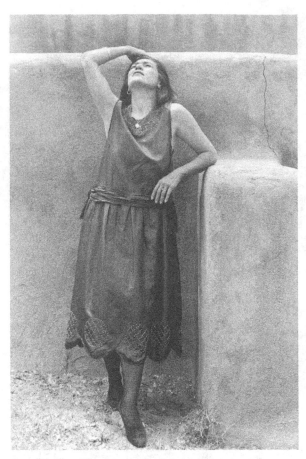

Ana Castillo, *Albuquerque, New Mexio,* 1992

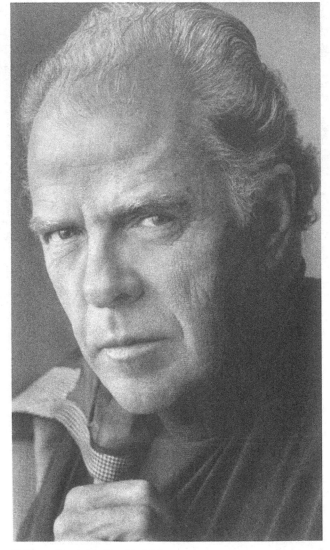

William Kennedy, *New York City,* 1995

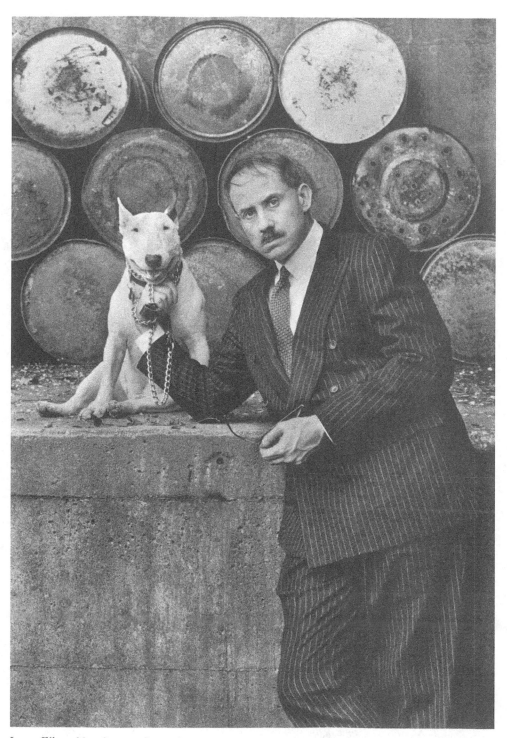

James Ellroy, *New Canaan, Connecticut,* 1992

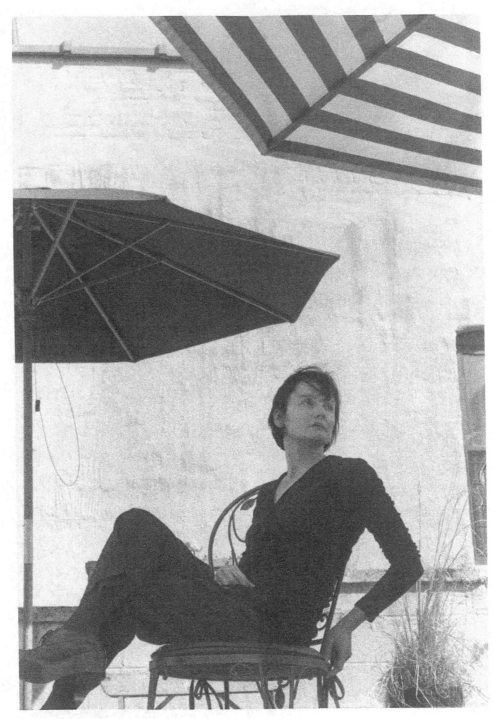

Jenefer Shute, *New York City*, 1996

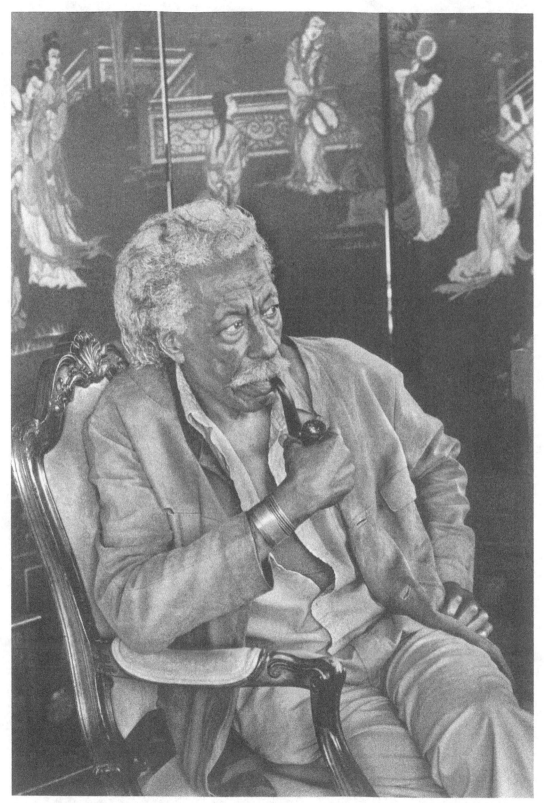

Gordon Parks, *New York City*, 1995

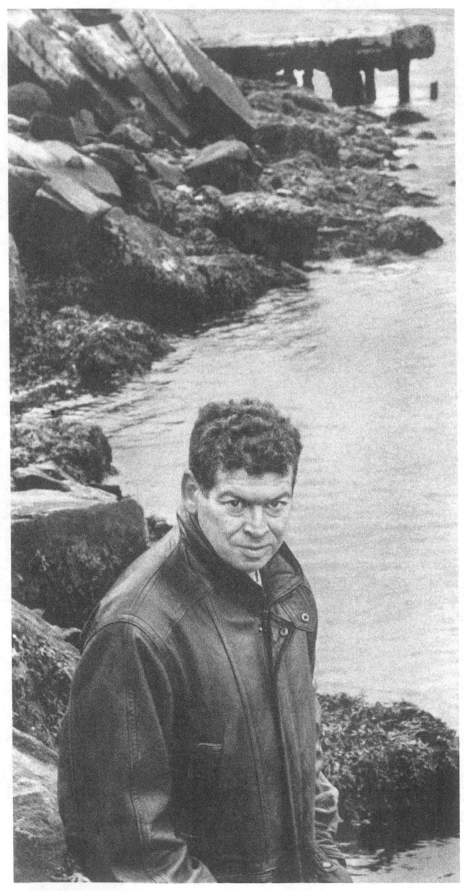

Francisco Goldman, *Red Hook, Brooklyn, New York*, 1996

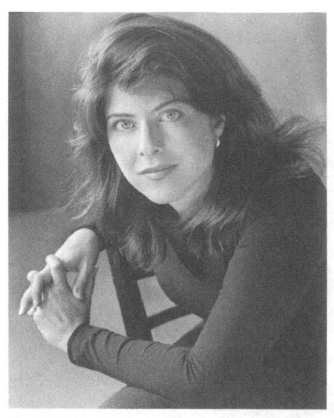

Naomi Wolf, *New York City*, 1997

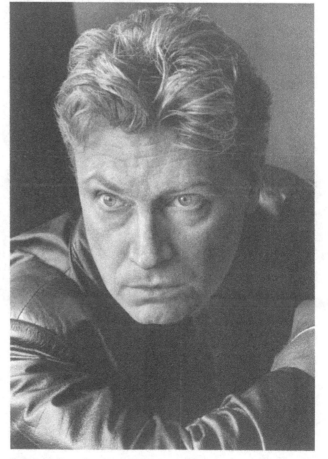

Robert Polito, *New York City*, 2000

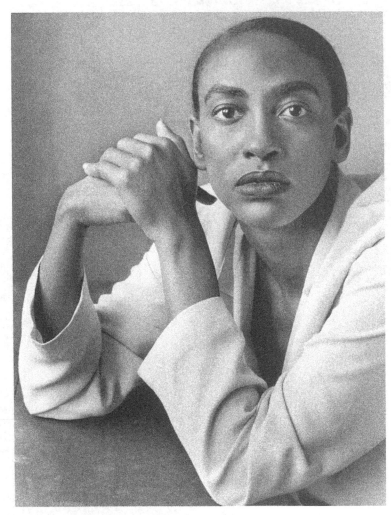

Loida Maritza Pérez, *New York City,* 1995

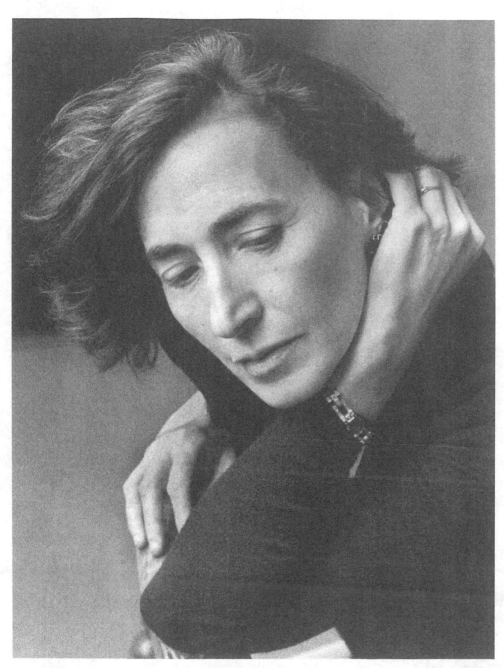

Francine Prose, *New York City*, 1999

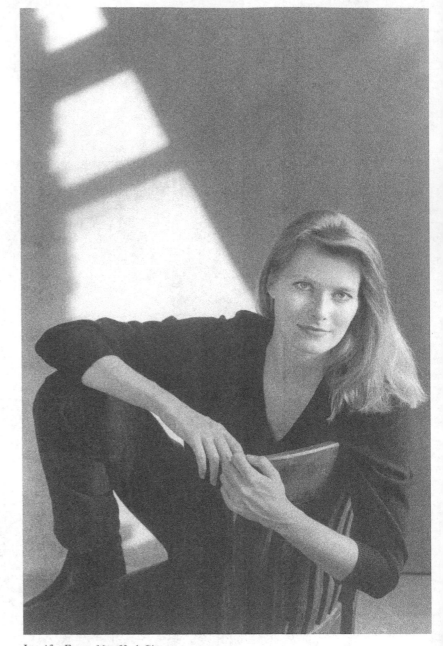

Jennifer Egan, *New York City*, 1994

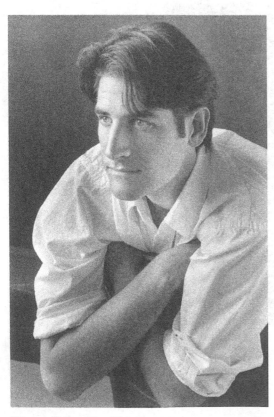

Thomas Beller, *New York City*, 1994

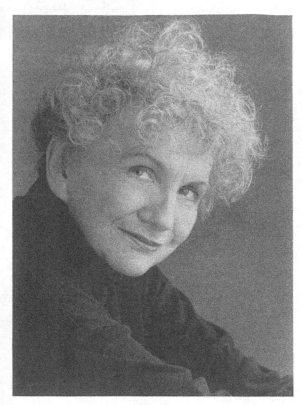

Alice Munro, *New York City*, 1994

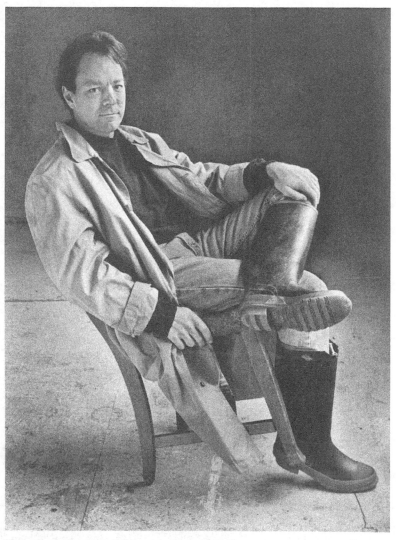

Tom Drury, *New York City*, 1993

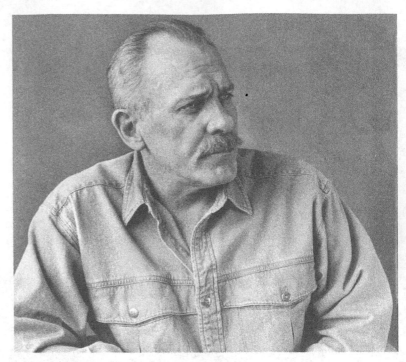

Thomas Steinbeck, *New York City*, 2002

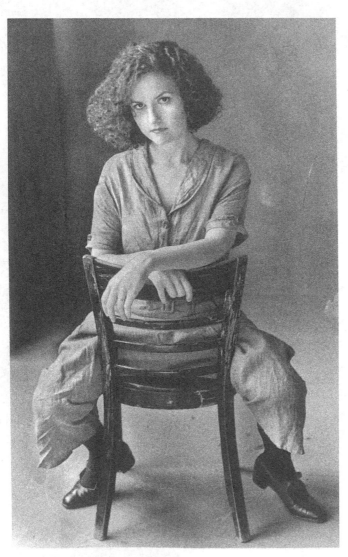

Rhian Ellis, *New York City*, 2000

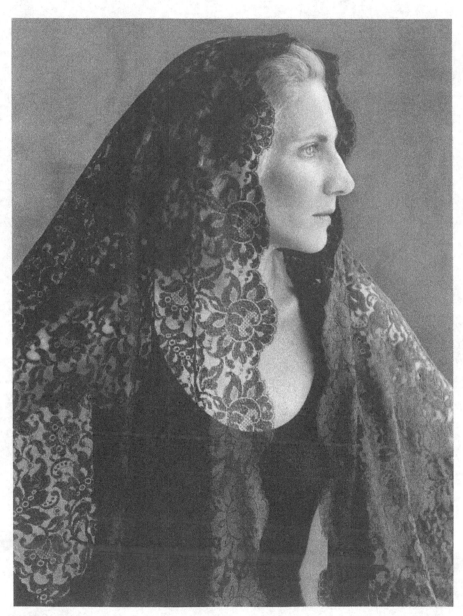

Kathryn Harrison, *New York City*, 1994

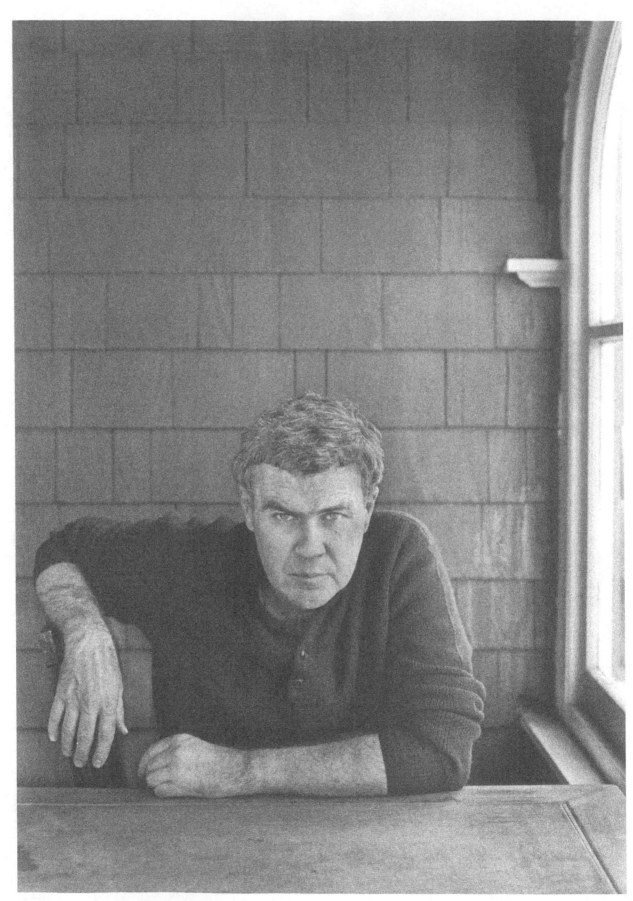

Raymond Carver, *Syracuse, New York*, 1984

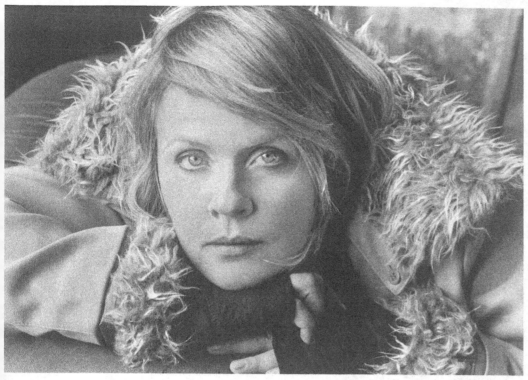

Nani Power, *New York City*, 2000

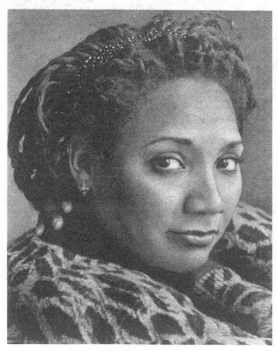

Debra J. Dickerson, *New York City*, 2000

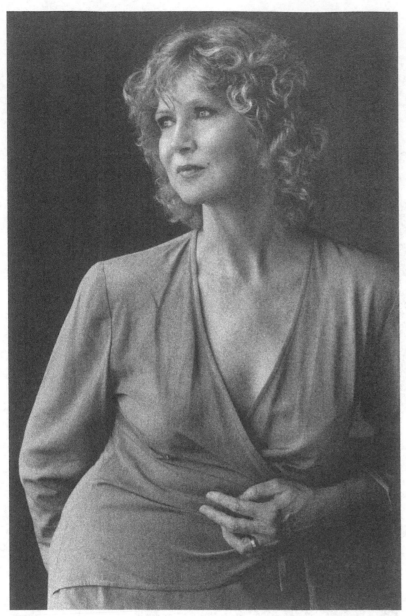

Sue Miller, *New York City,* 1998

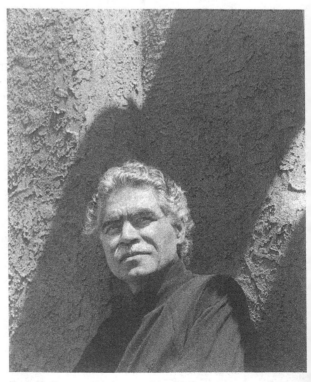

Rudolfo Anaya, *Albuquerque, New Mexico,* 1992

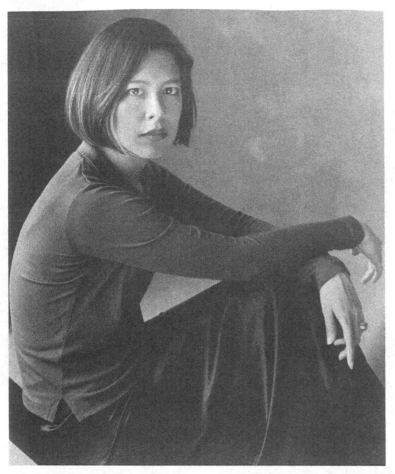

Susan Choi, *New York City*, 1998

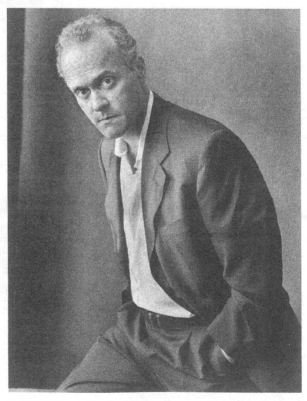

W. S. Di Piero, *New York City*, 2000

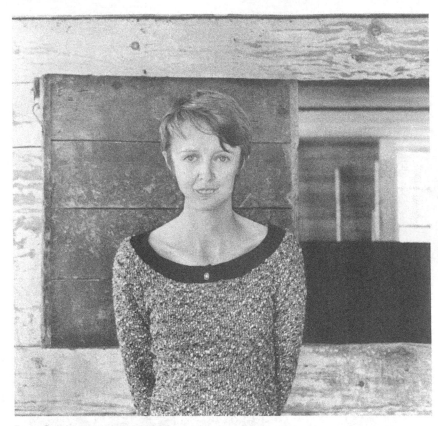

Lucy Grealy, *Wilton, Connecticut,* 2000

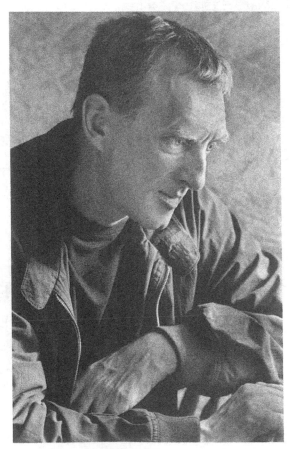

James Kelman, *Austin, Texas,* 1998

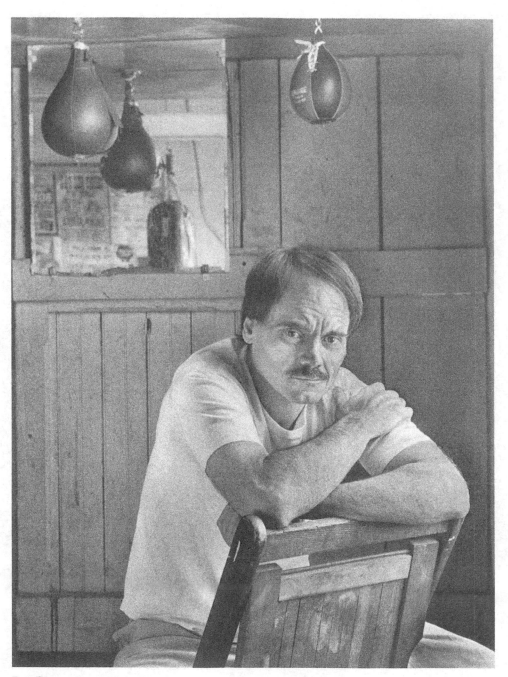

Pete Dexter, *Rosati's Gym, Philadelphia, Pennsylvania*, 1991

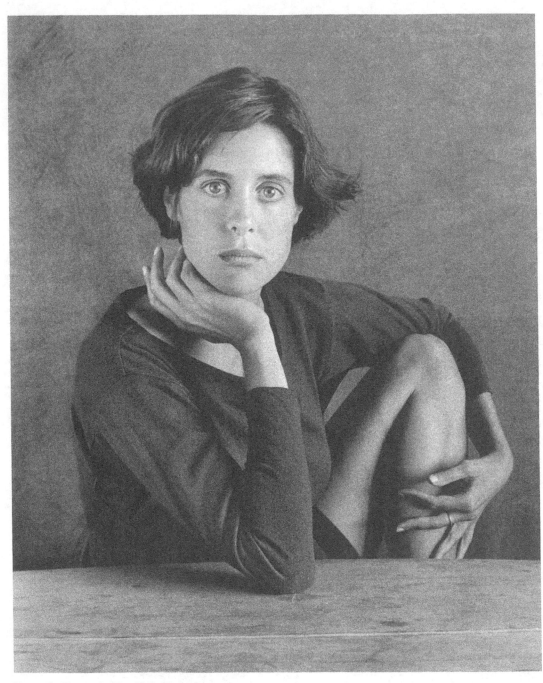

Fernanda Eberstadt, *New York City*, 1990

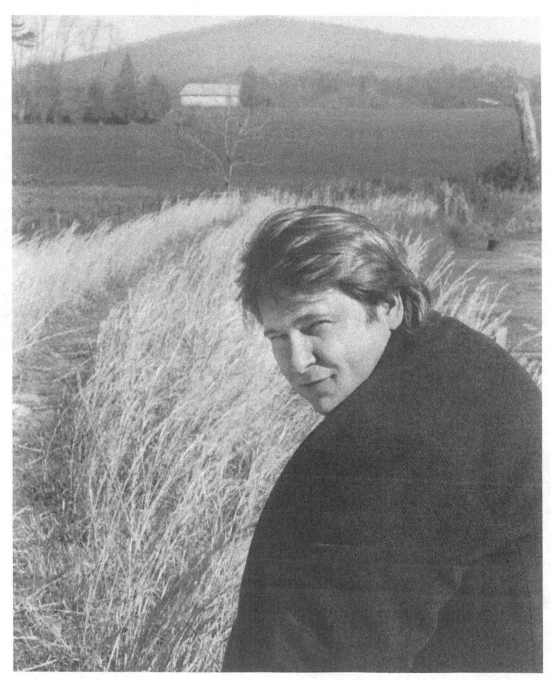

Rick Bragg, *Calhoun County, Alabama*, 1997

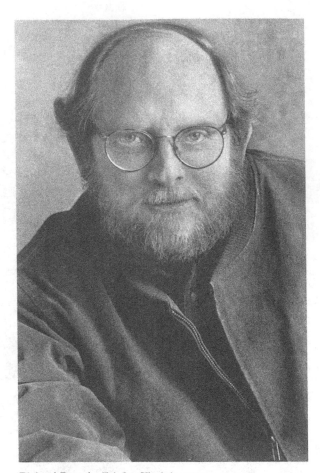

Richard Bausch, *Fairfax, Virginia,* 1997

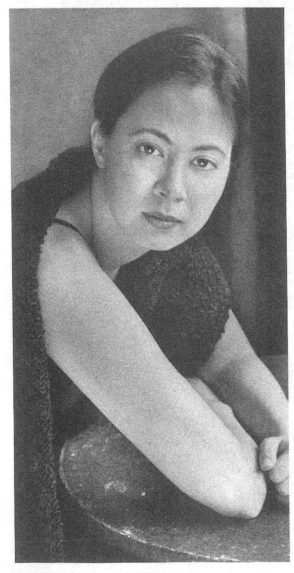

Paisley Rekdal, *New York City,* 2000

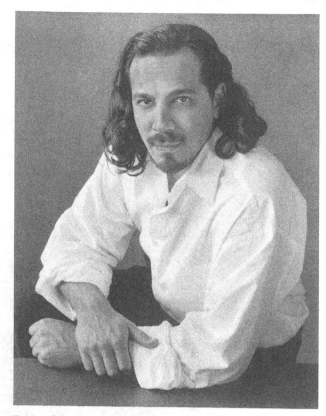

Reuben Martinez, *New York City*, 1995

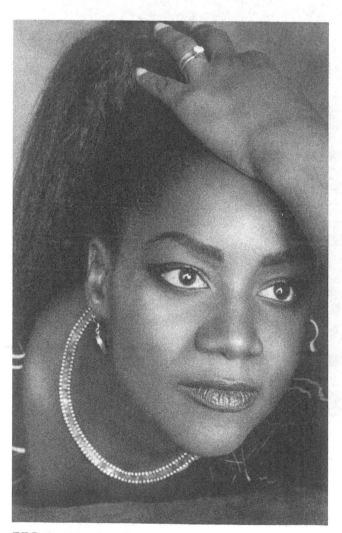

ZZ Packer, *New York City*, 2002

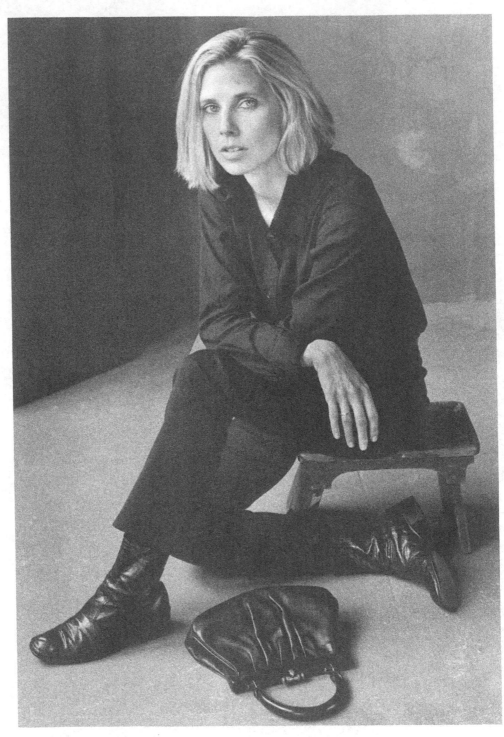

Darcey Steinke, *New York City*, 1997

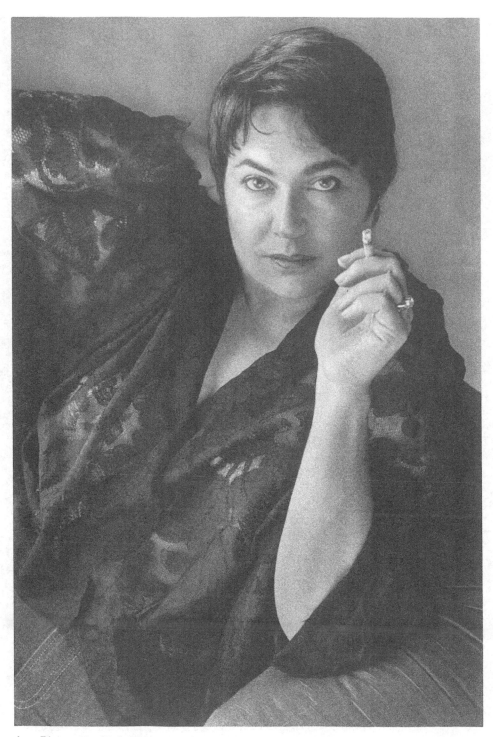

Amy Bloom, *New York City*, 1999

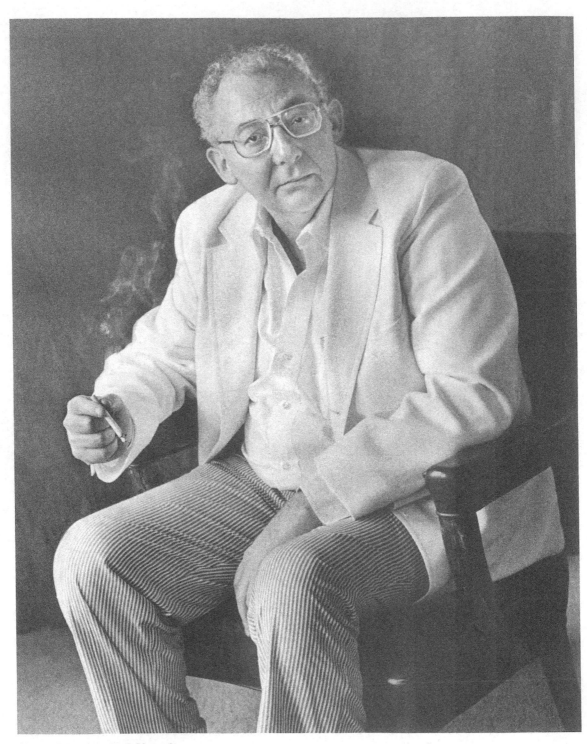

Stanley Elkin, *New York City*, 1983

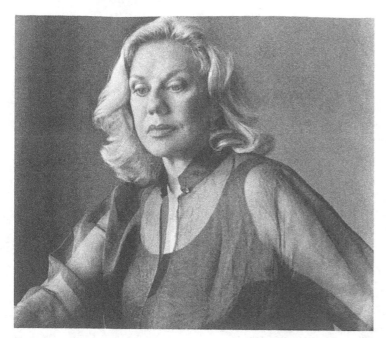

Erica Jong, *New York City*, 2002

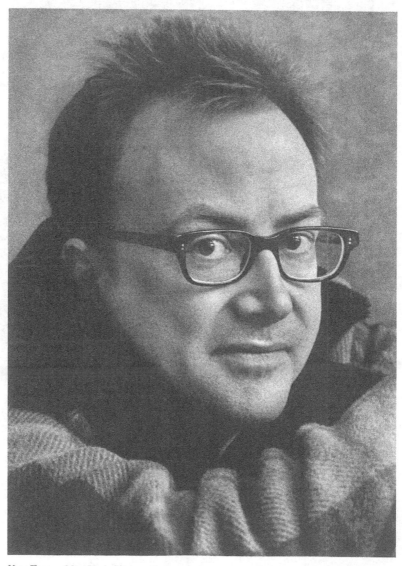

Ken Foster, *New York City*, 1998

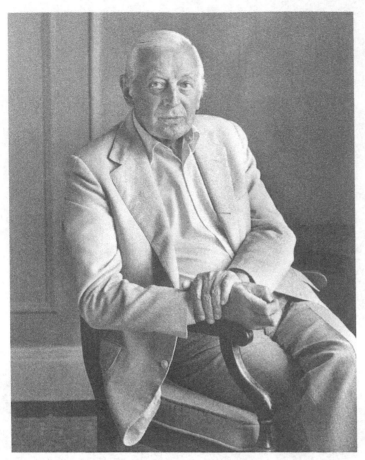

Alistair Cooke, *New York City*, 1983

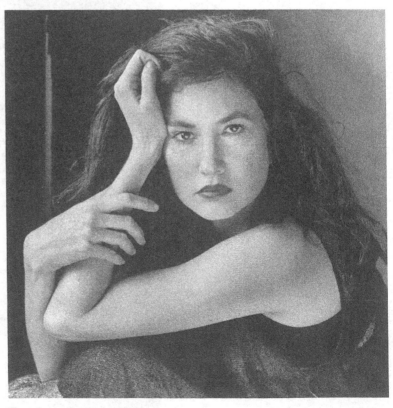

Tama Janowitz, *New York City*, 1998

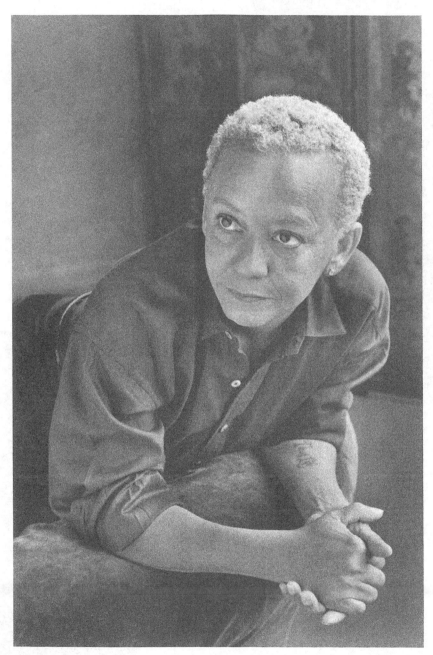

Nikki Giovanni, *New York City*, 1998

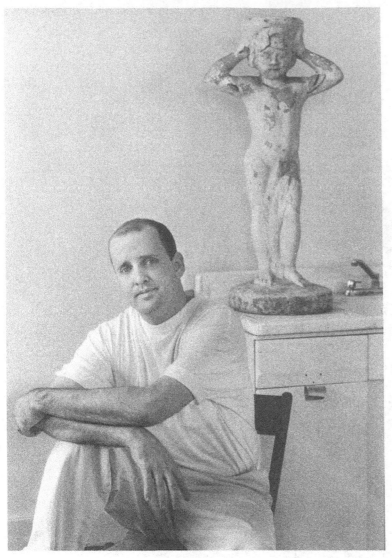

Tony Earley, *Ambridge, Pennsylvania*, 1996

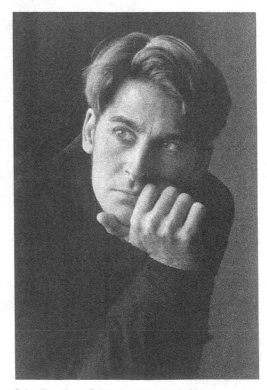

John Burnham Schwartz, *New York City*, 1997

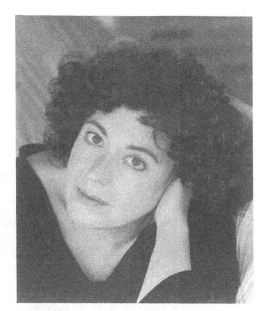

Susan Isaacs, *Sands Point, New York*, 1995

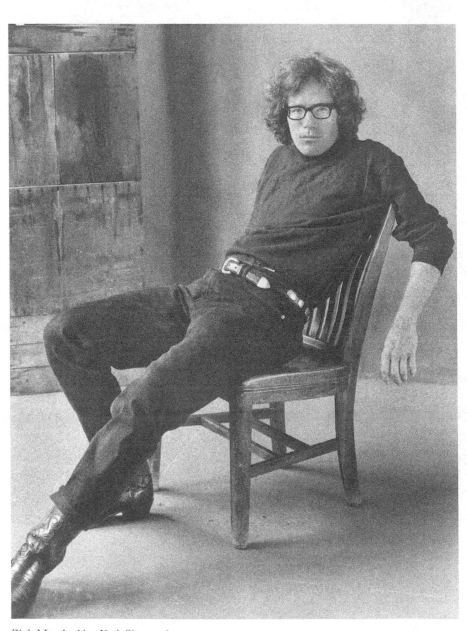

Rick Moody, *New York City*, 1996

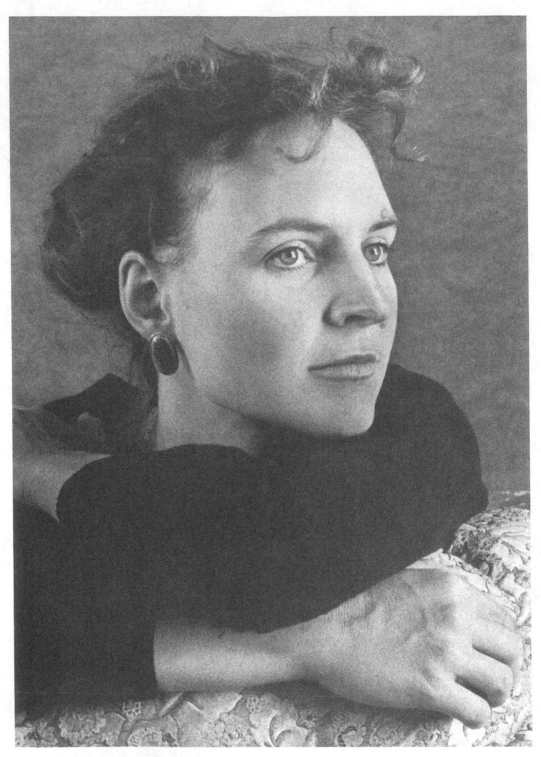

Antonya Nelson, *Las Cruces, New Mexico*, 1992

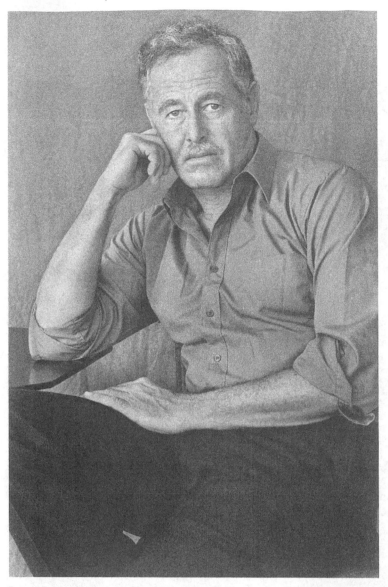

James Salter, *Sagaponack, New York*, 1983

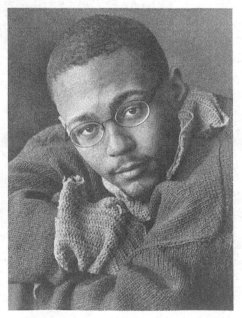

Victor La Valle, *New York City*, 1999

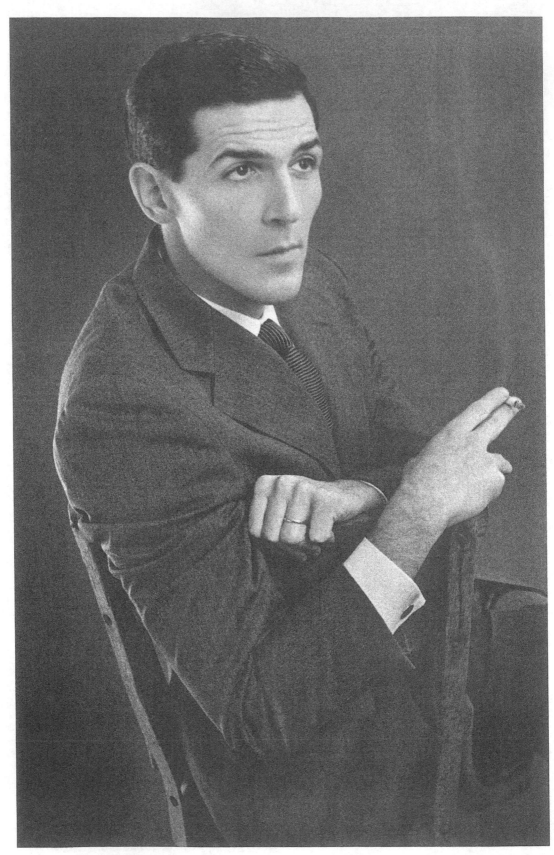

G. D. Dess, *New York City*, 1987

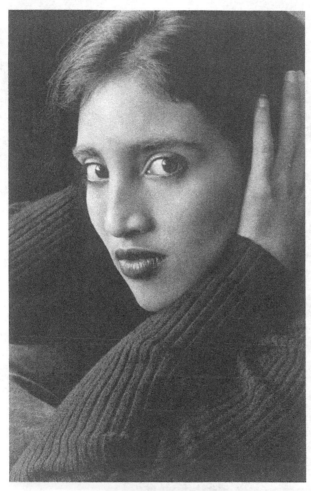

Suneeta Peres da Costa, *New York City*, 1999

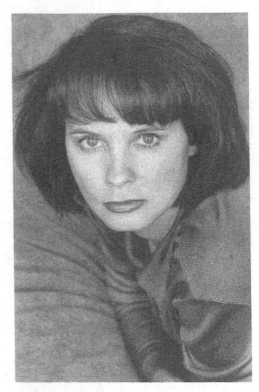

Mary Gaitskill, *New York City,* 1996

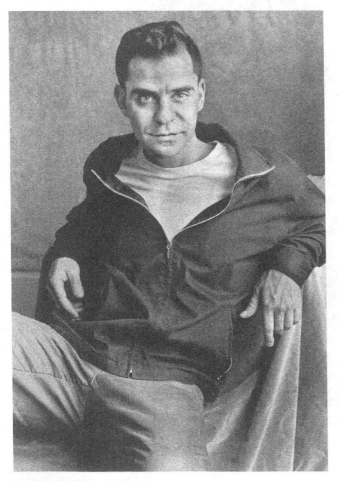

David Rakoff, *New York City,* 2000

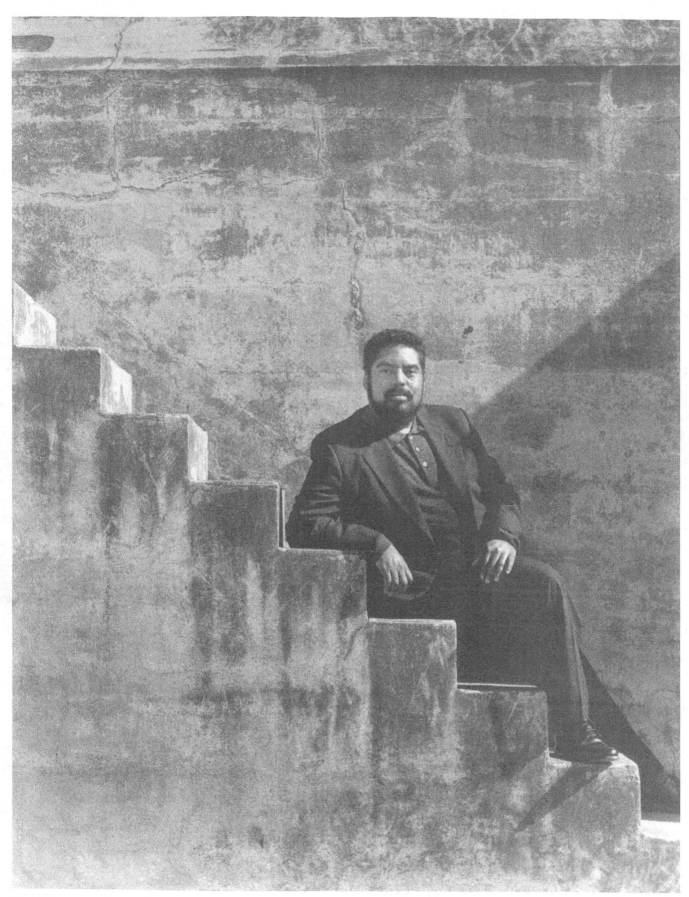

David Haynes, *Fort Worden, Port Townsend, Washington,* 1996

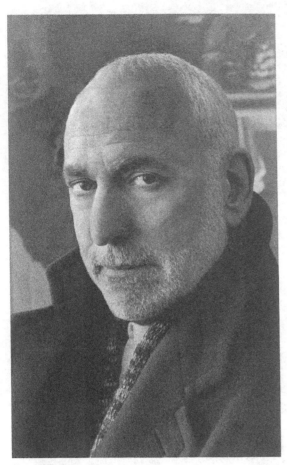

David M. Friedman, *New York City*, 2001

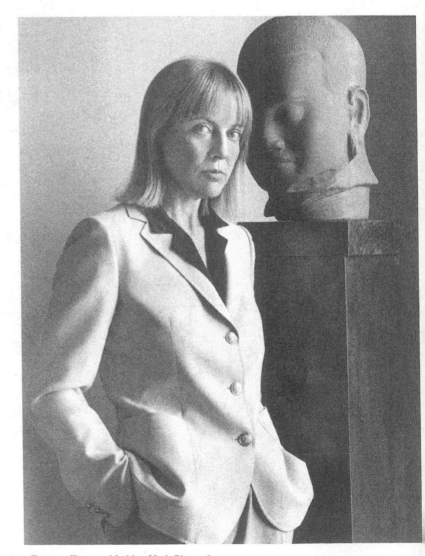

Frances Fitzgerald, *New York City*, 1983

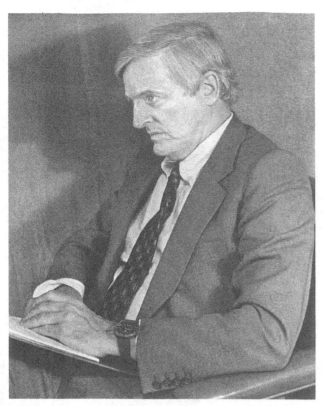

William F. Buckley Jr., *New York City,* 1983

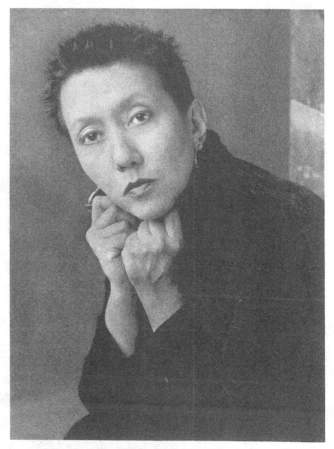

Jessica Hagedorn, *New York City,* 1996

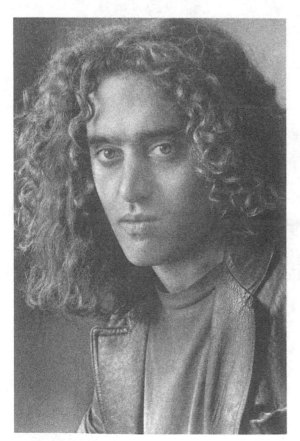

Nathan Englander, *New York City,* 1998

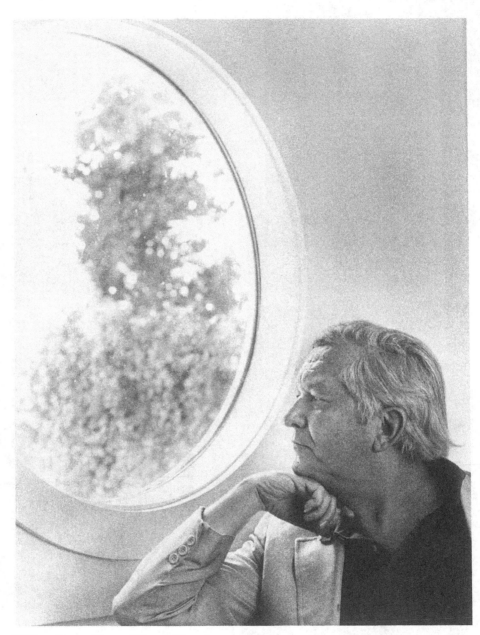

William Styron, *Vineyard Haven, Massachusetts,* 1983

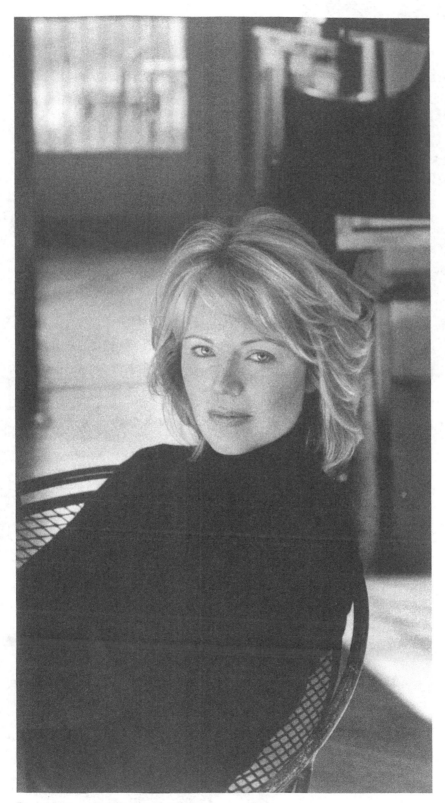

Dani Shapiro, *Brooklyn, New York*, 2002

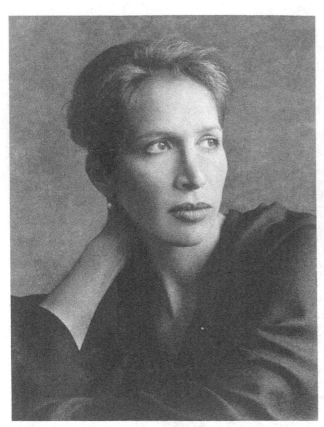

Emily Benedek, *New York City*, 2000

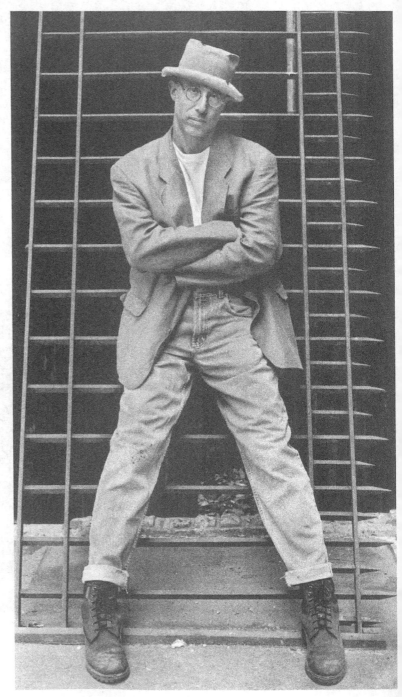

Joel Rose, *East River Park, New York City*, 1996

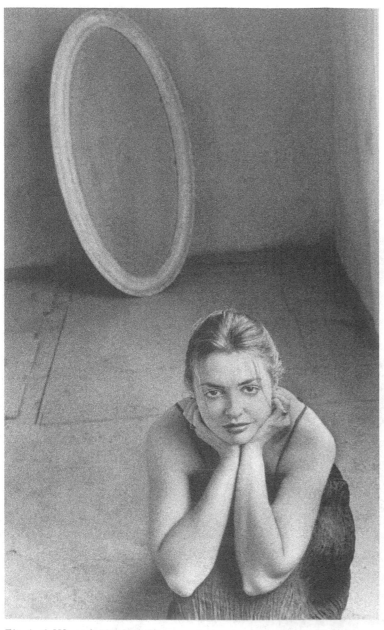

Elizabeth Wurtzel, *New York City*, 1994

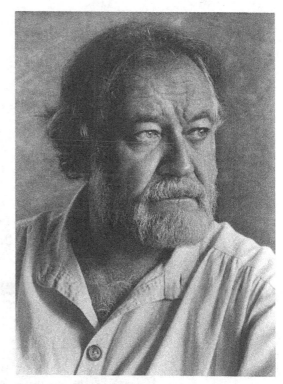

James Crumley, *Missoula, Montana*, 1989

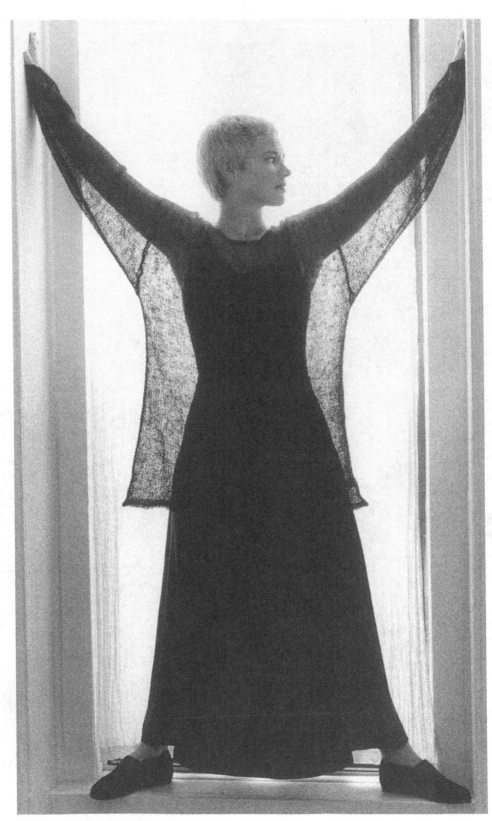

Karin Cook, *Brooklyn, New York*, 1996

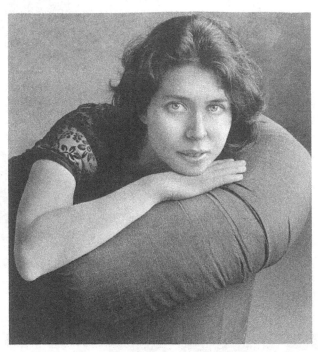

Allegra Goodman, *New York City*, 1998

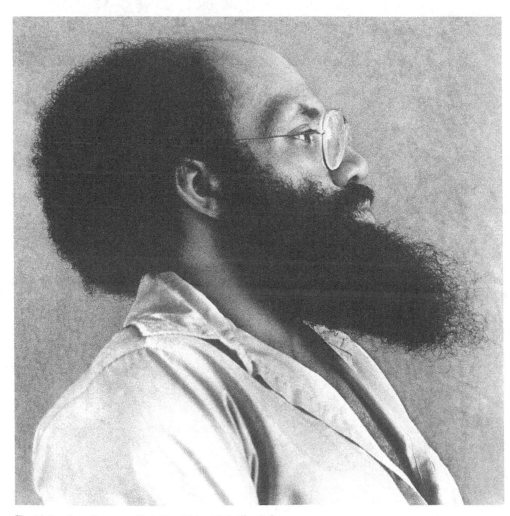

David Bradley, *Gramercy Park Hotel, New York City*, 1983

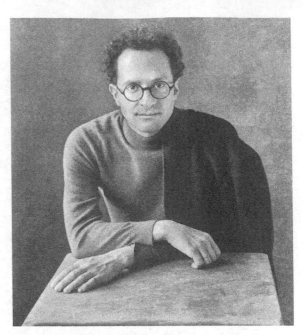

Wayne Koestenbaum, *New York City*, 1994

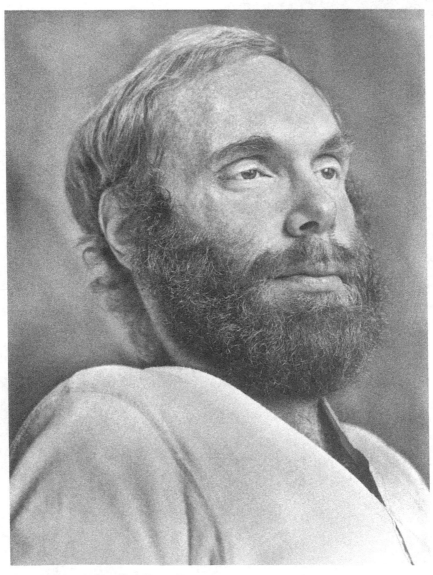

Ron Rosenbaum, *New York City*, 1983

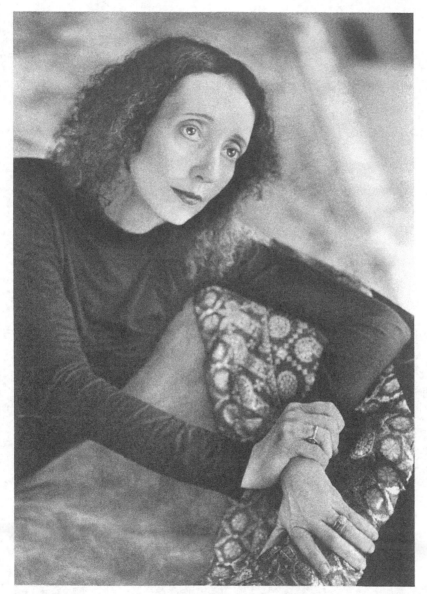

Joyce Carol Oates, *Princeton, New Jersey,* 1999

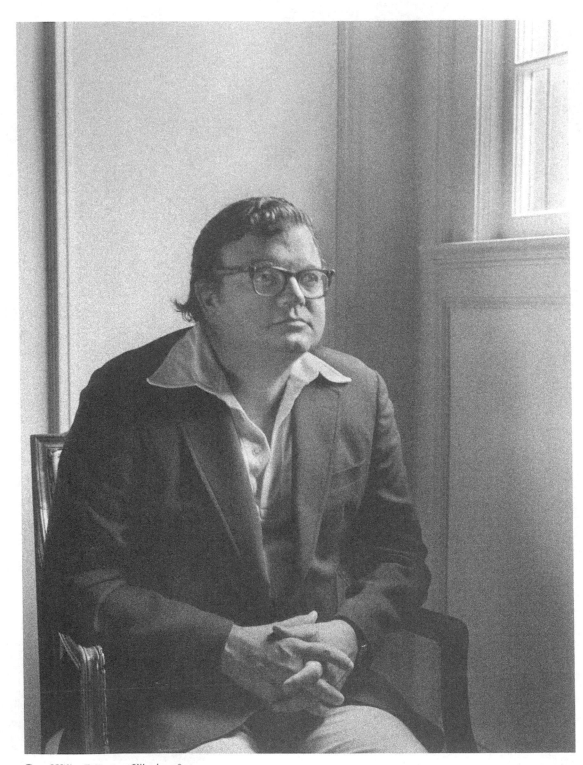

Gary Wills, *Evanston, Illinois,* 1983

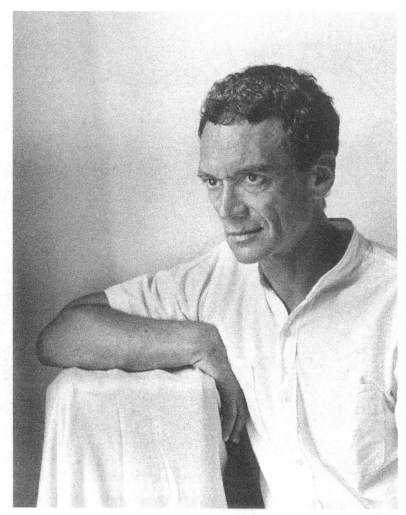

Ronald Steel, *New York City*, 1983

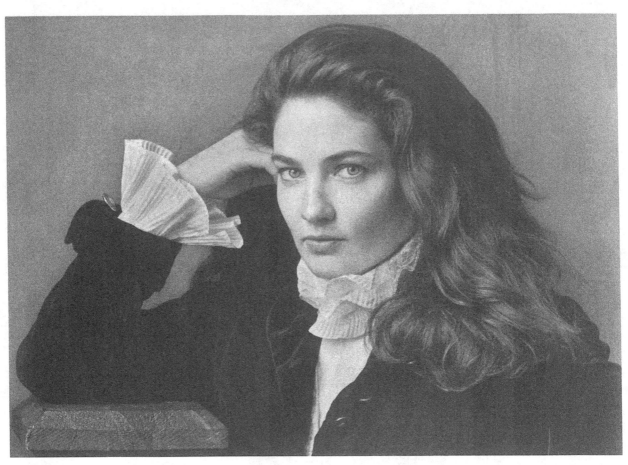

A. M. Homes, *New York City*, 1995

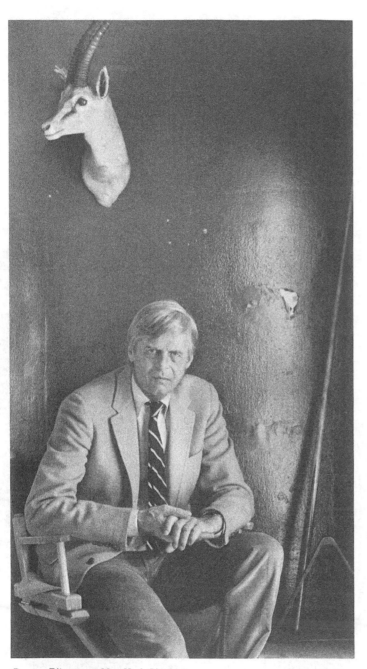

George Plimpton, *New York City,* 1983

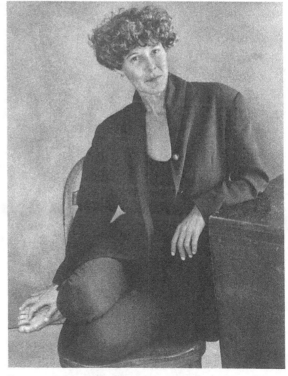

Susanna Kaysen, *New York City,* 1993

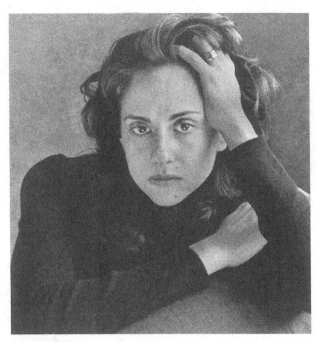

Helen Schulman, *New York City*, 2000

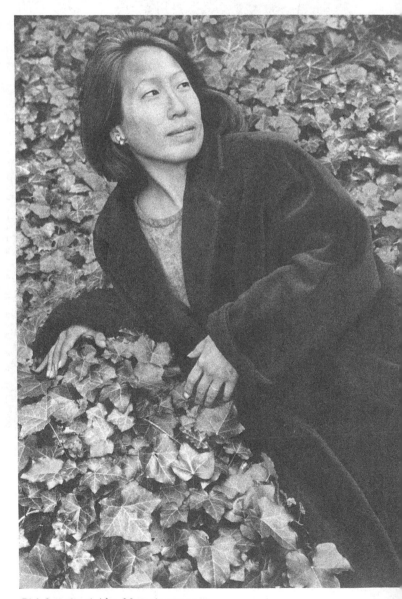

Gish Jen, *Cambridge, Massachusetts*, 1995

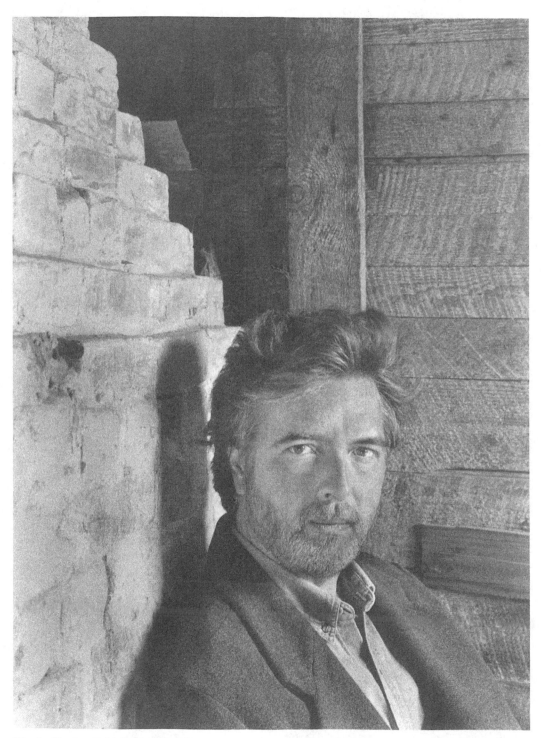

Charles Frazier, *Raleigh, North Carolina*, 1997

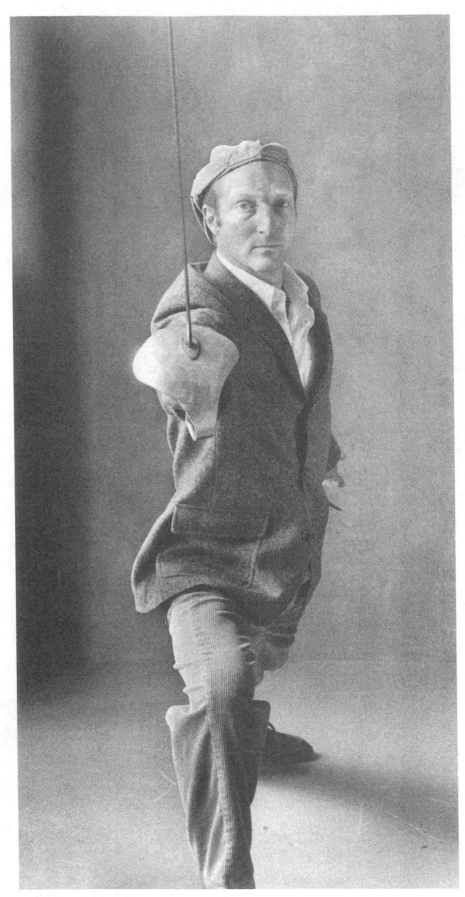

Jonathan Ames, *New York City*, 2002

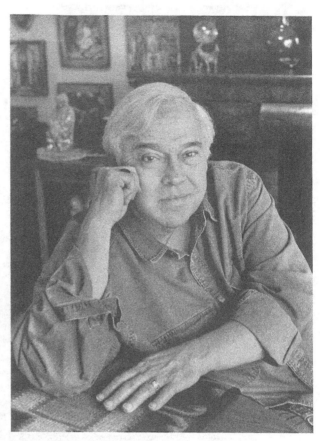

Reynolds Price, *Durham, North Carolina*, 1997

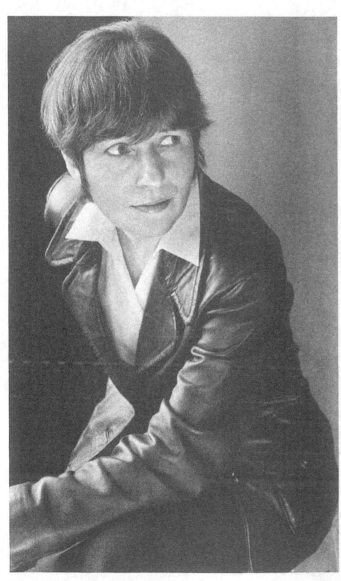

Carol O'Connell, *New York City*, 2002

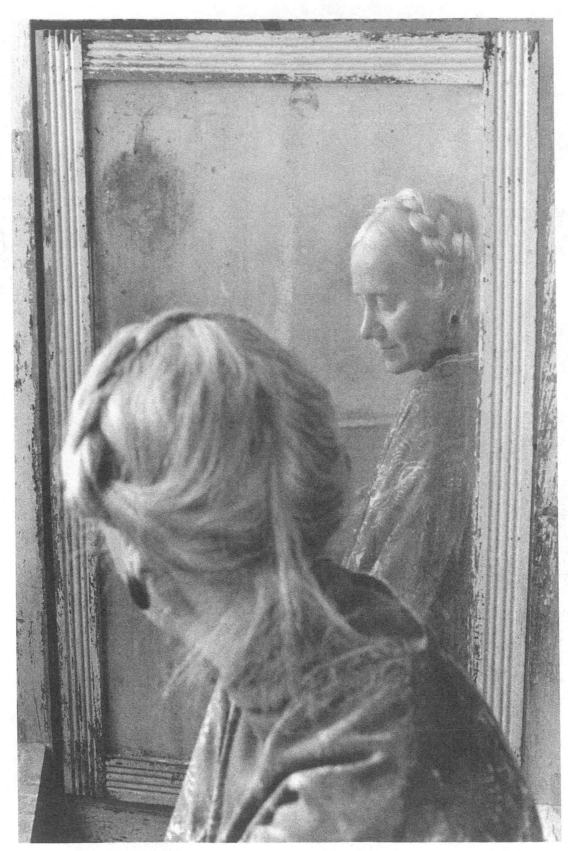

Frances Kiernan, *New York City*, 1995

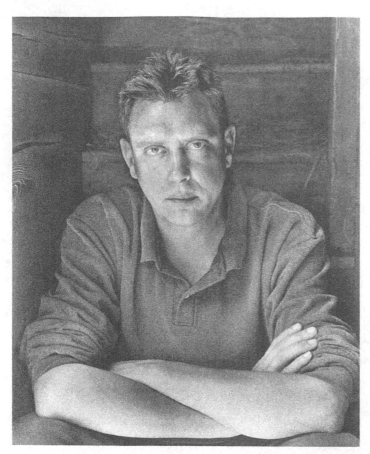

Jeffrey Lent, *Tunbridge, Vermont*, 1999

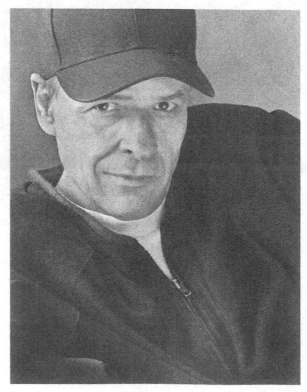

Tim O'Brien, *New York City*, 2002

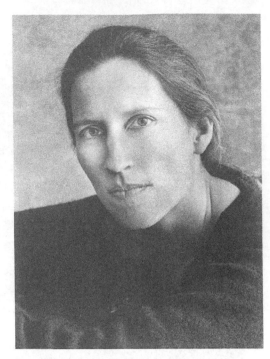

Jane Hamilton, *New York City*, 2000

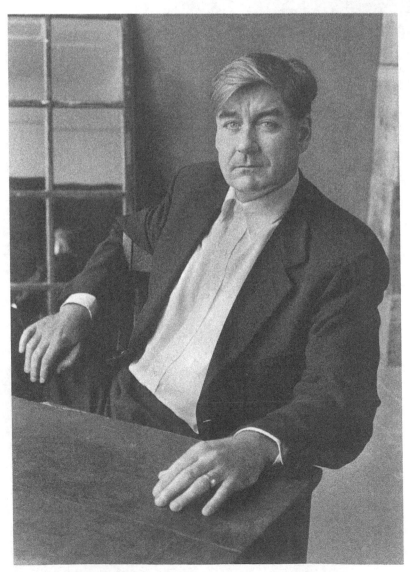

Patrick McGrath, *New York City*, 1996

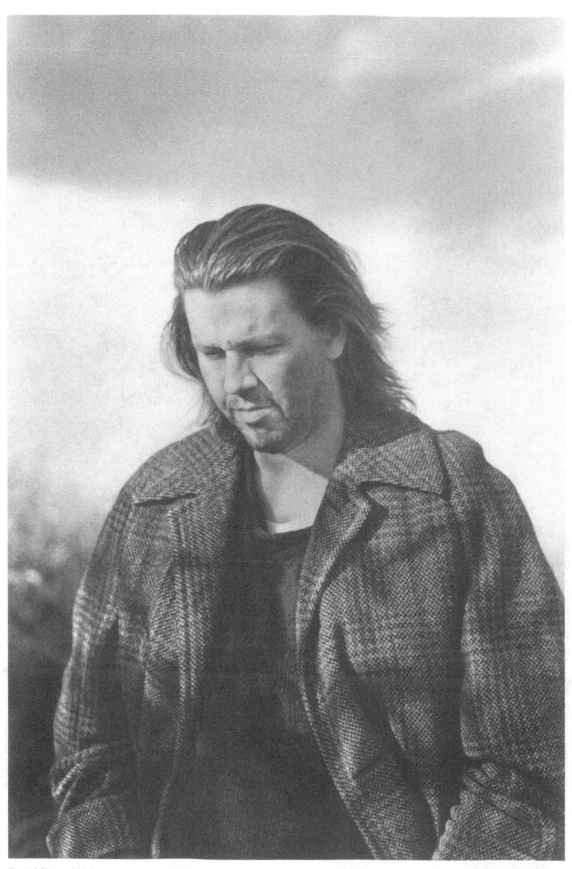

David Foster Wallace, *Bloomington, Illinois,* 2001

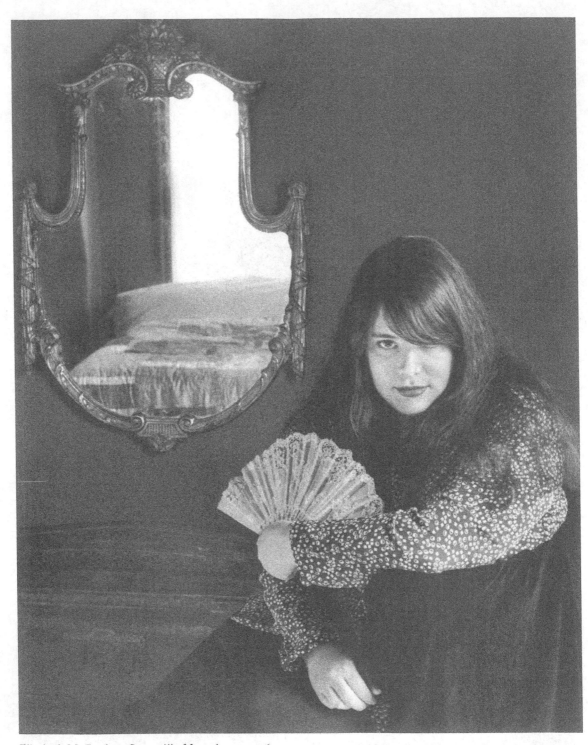

Elizabeth McCracken, *Somerville, Massachusetts,* 1996

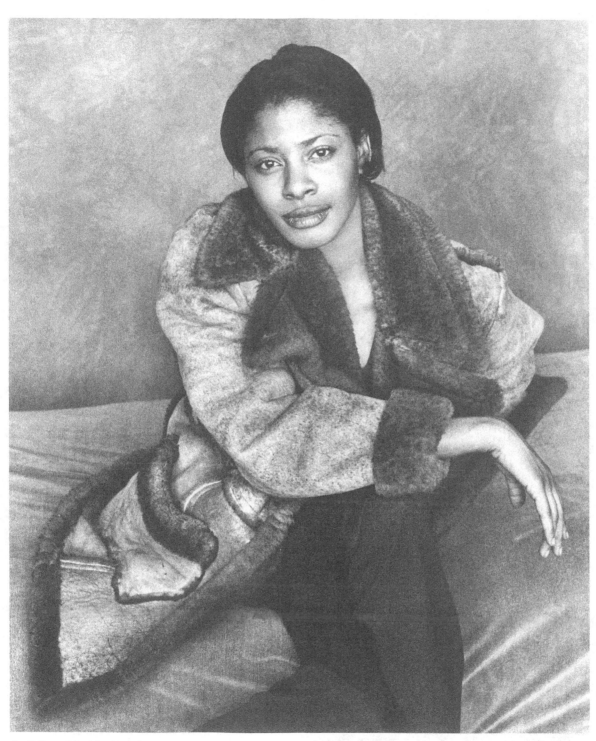

April Reynolds, *New York City*, 2002

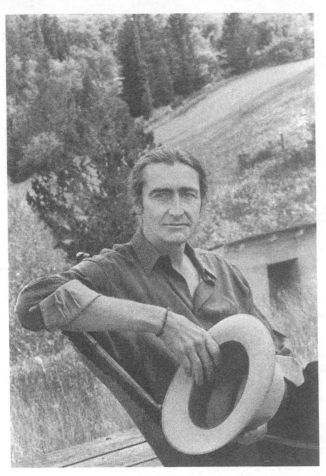

William Hjortsberg, *Lion Head Cabin, Montana*, 1989

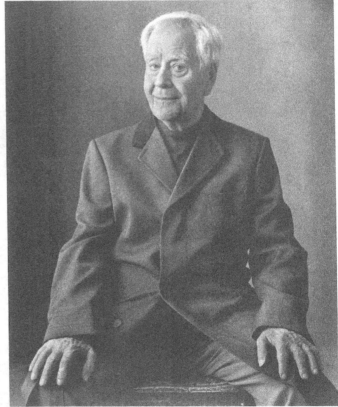

Horton Foote, *New York City*, 1998

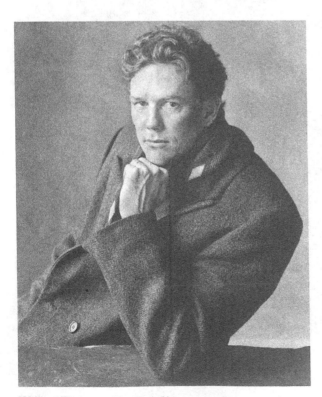

William Finnegan, *New York City*, 1997

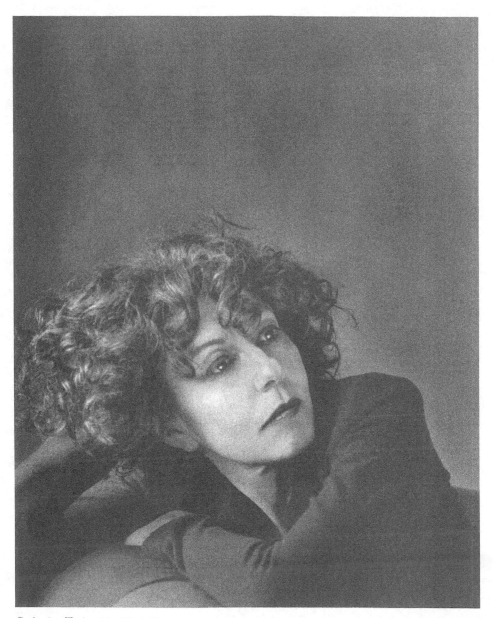

Catherine Texier, *New York City*, 1997

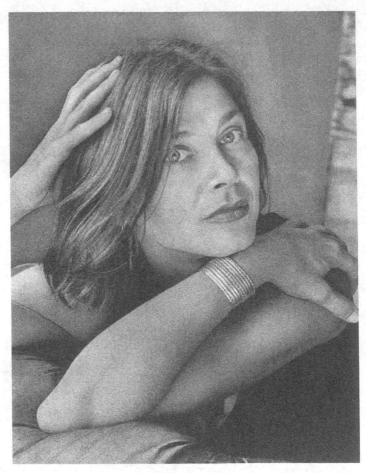

Francesca Marciano, *New York City*, 1997

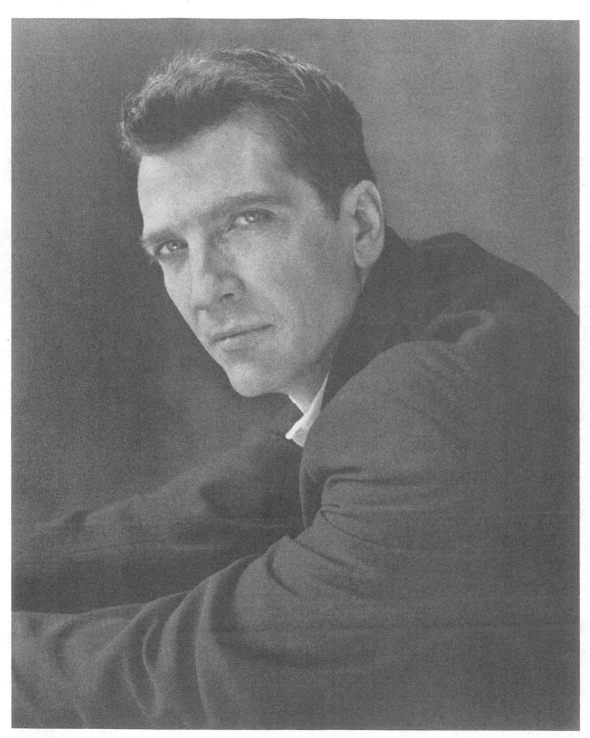

Steven Rinehart, *New York City*, 1999

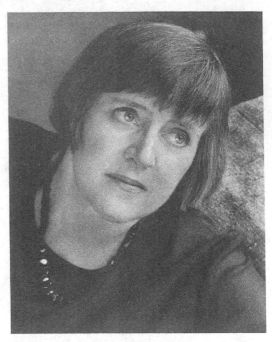

Kathleen Norris, *New York City*, 2001

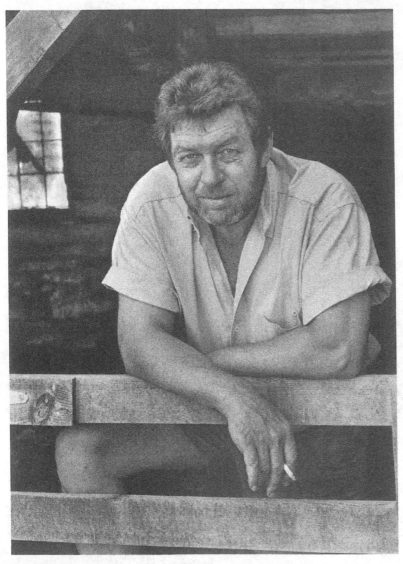

Pete Hamill, *Wallkill, New York*, 1989

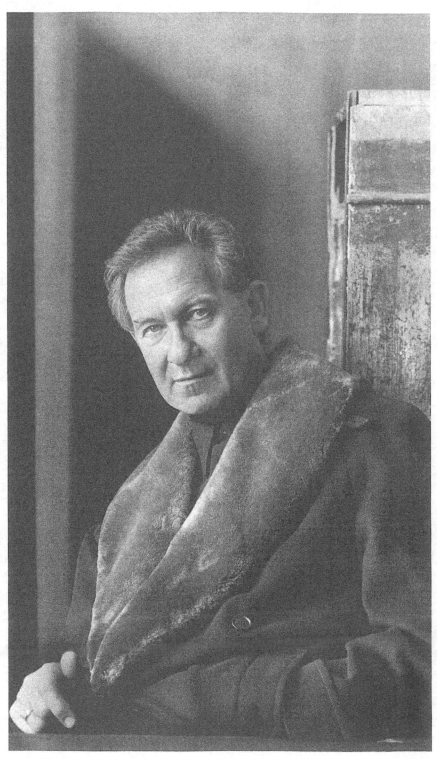

Simon Schama, *New York City*, 1999

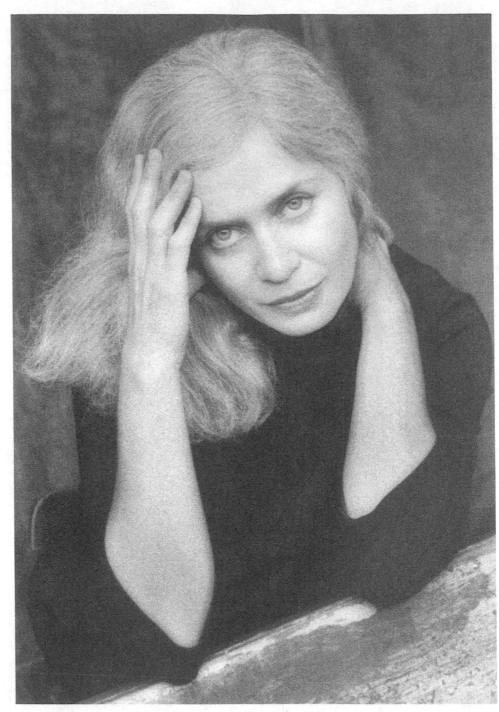

Amy Hempel, *New York City*, 2001

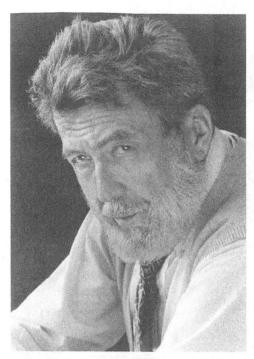

Nat Hentoff, *New York City*, 1997

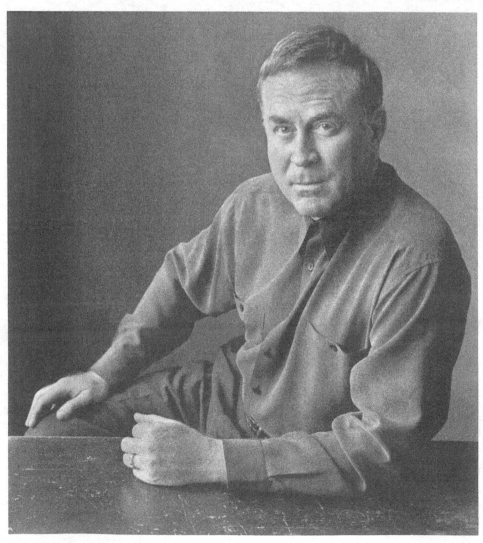

Richard Rhodes, *New York City*, 1999

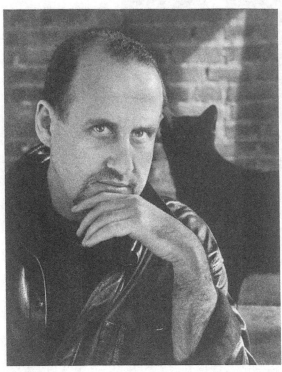

Bruce Benderson, *New York City,* 1994

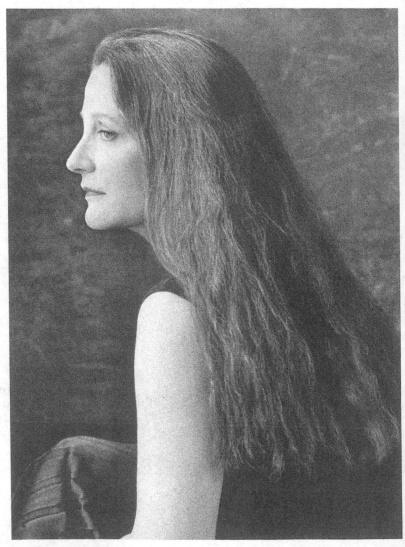

Jayne Anne Phillips, *Newton, Massachusetts,* 1994

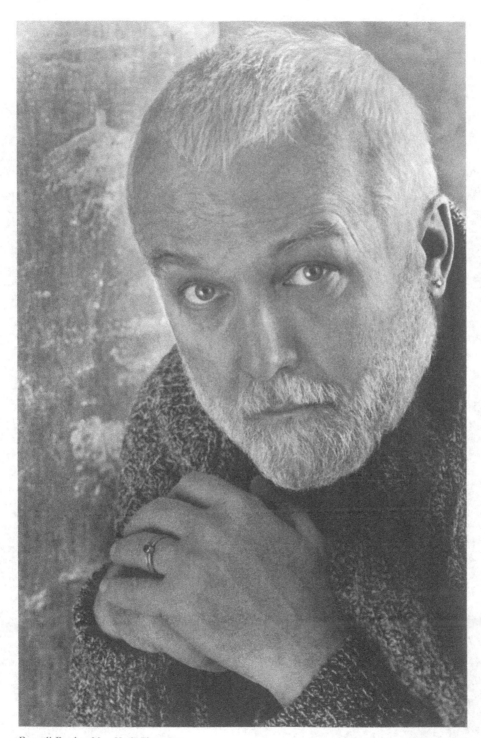

Russell Banks, *New York City,* 1999

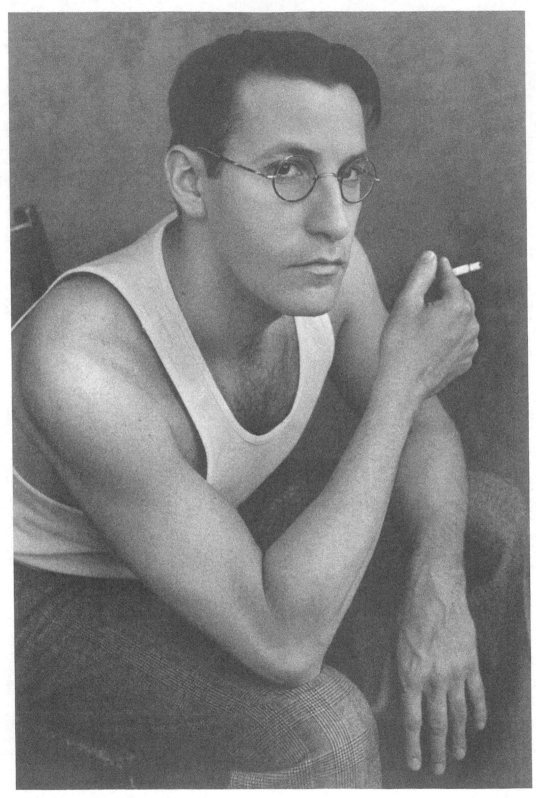

Chip Kidd, *New York City*, 2001

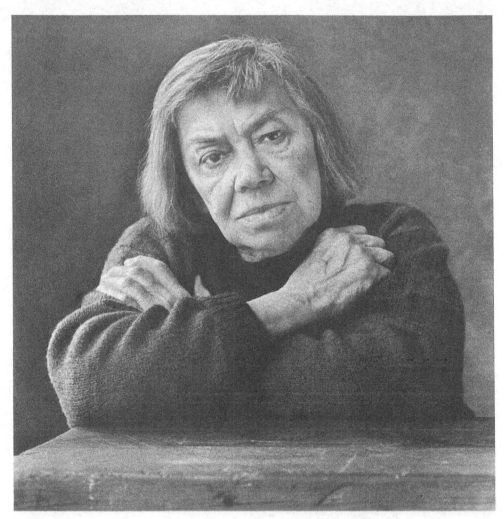

Patricia Highsmith, *New York City*, 1992

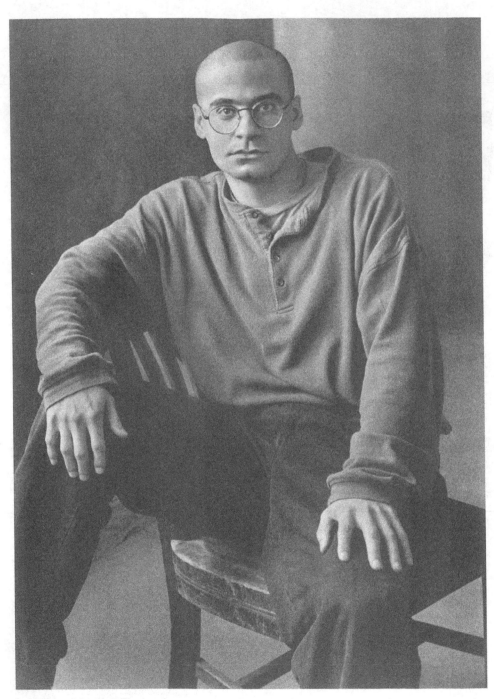

Junot Diaz, *New York City,* 1996

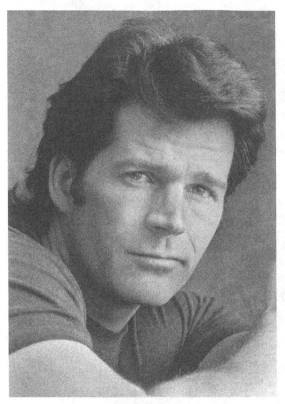

Andre Dubus III, *New York City*, 1998

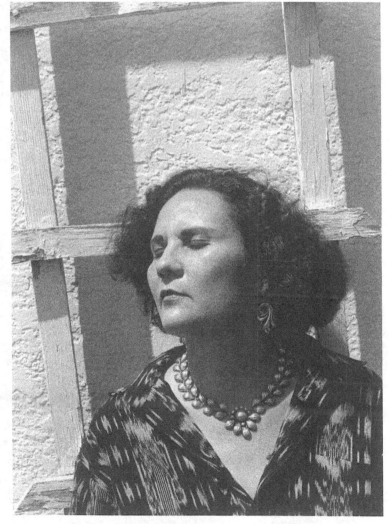

Denise Chavez, *Las Cruces, New Mexico*, 1992

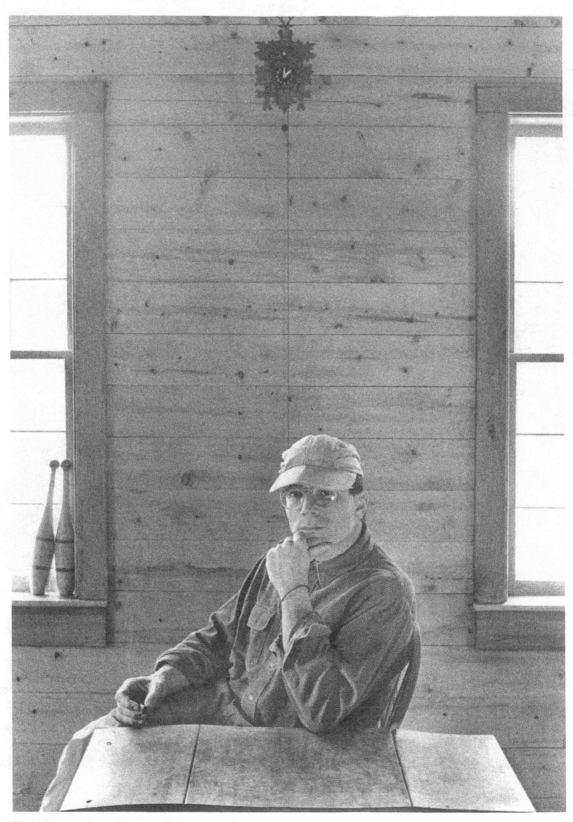

David Mamet, *Cabot, Vermont*, 1987

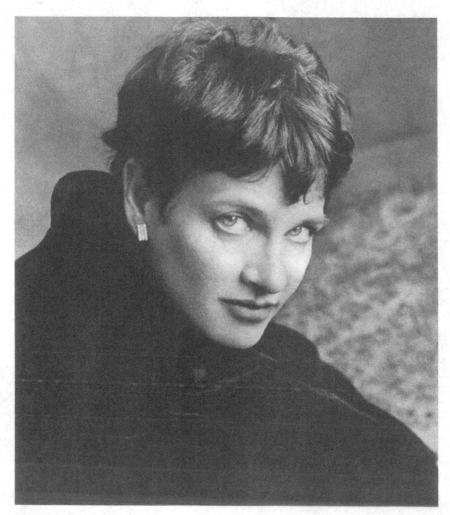

Sarah Boxer, *New York City*, 2001

Abraham Verghese, *New York City*, 1993

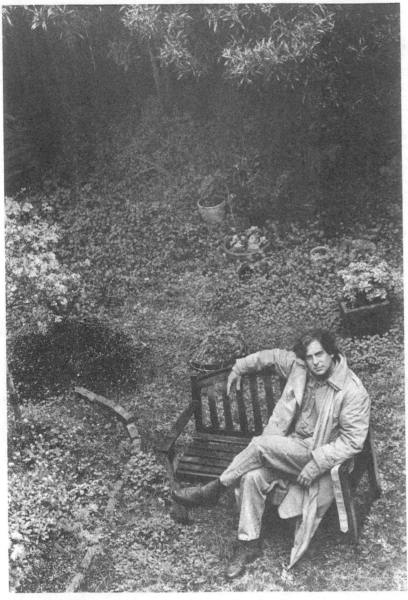

Ethan Canin, *San Francisco*, 1996

Jill Bialosky, *New York City*, 2001

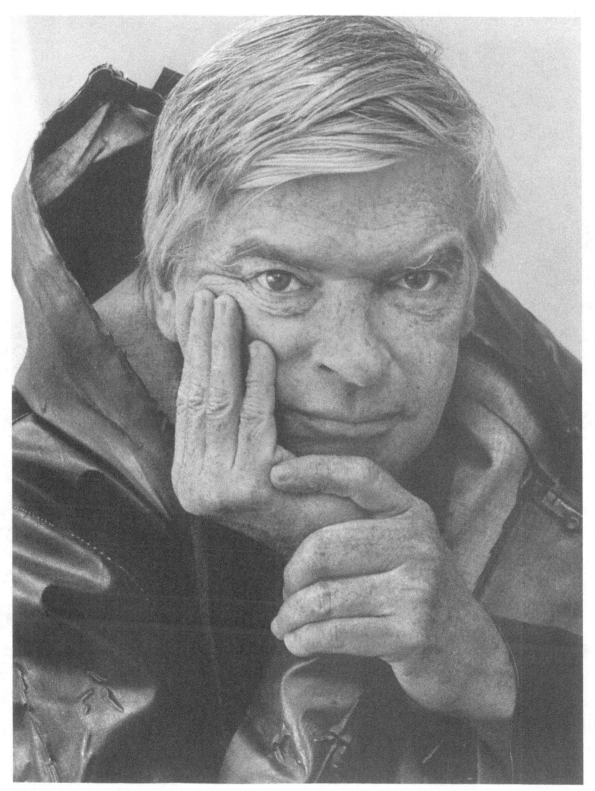

Frank Conroy, *Nantucket, Massachusetts*, 1993

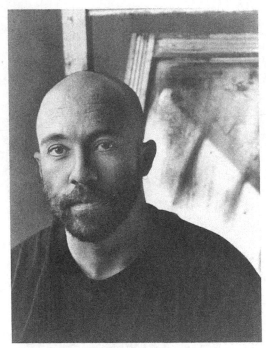

Max Phillips, *New York City*, 1995

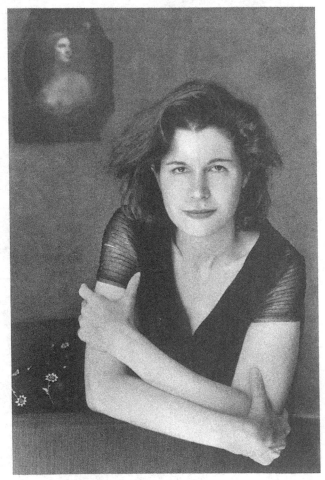

Christina Bartolomeo, *Washington, D.C.*, 1997

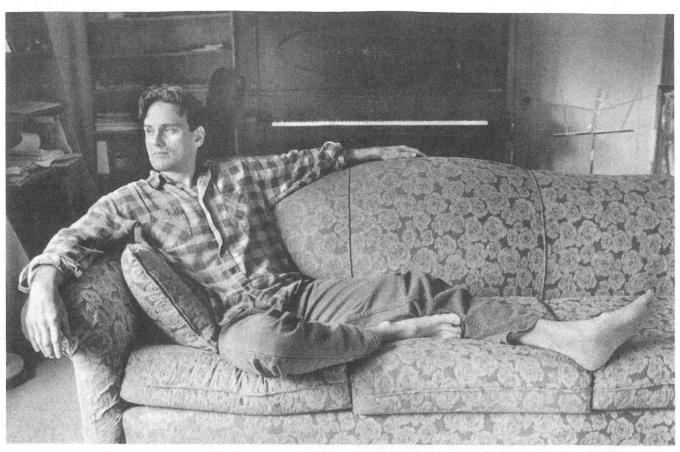

David Guterson, *Bainbridge Island, Washington*, 1996

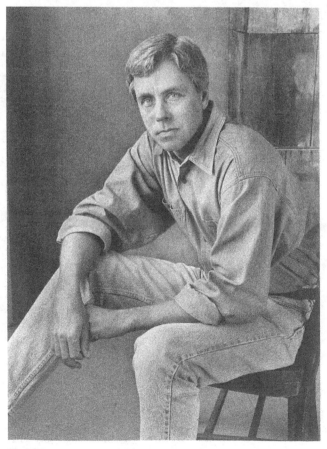

Carl Hiaasen, *New York City*, 1995

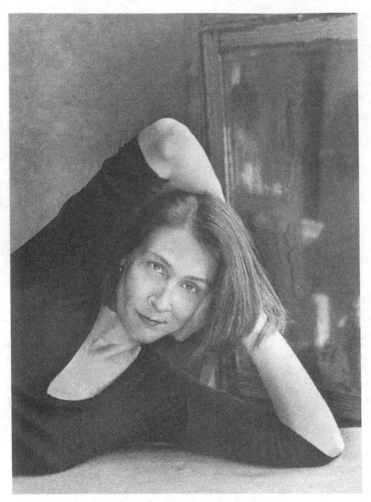

Elizabeth Stuckey-French, *New York City*, 1999

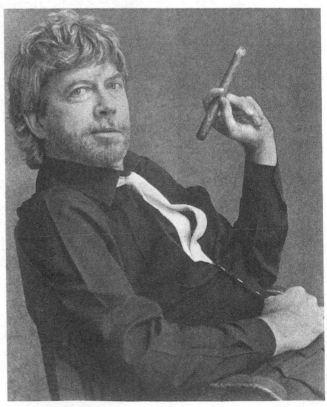

Tom Robbins, *La Conner, Washington*, 1983

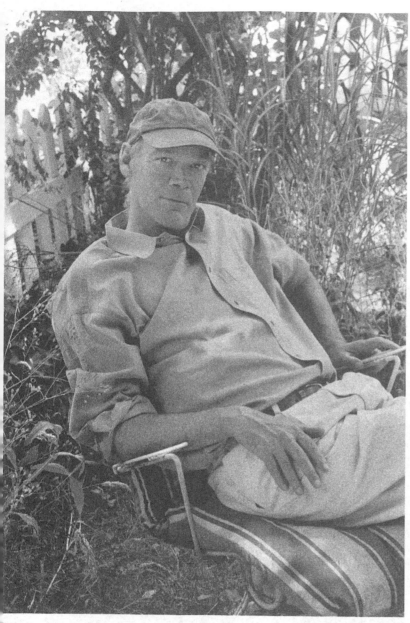

Jonathan Raban, *Seattle, Washington*, 1997

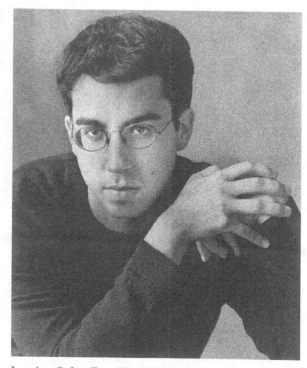

Jonathan Safran Foer, *New York City*, 2001

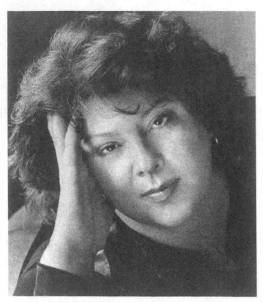

Jean Thompson, *New York City*, 2000

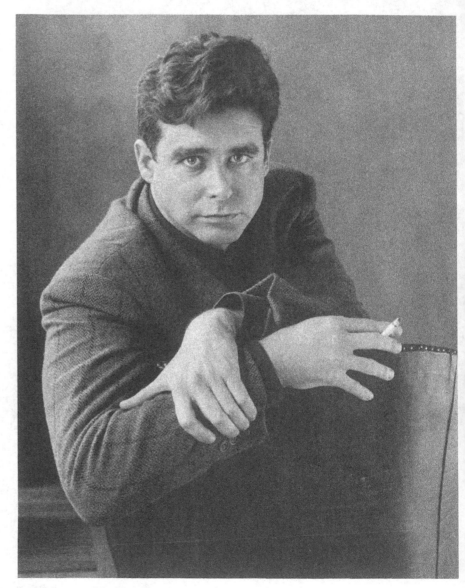

Jay McInerney, *New York City*, 1991

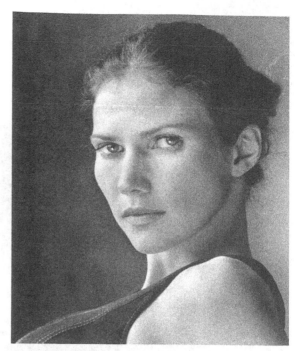

Galaxy Craze, *New York City*, 1998

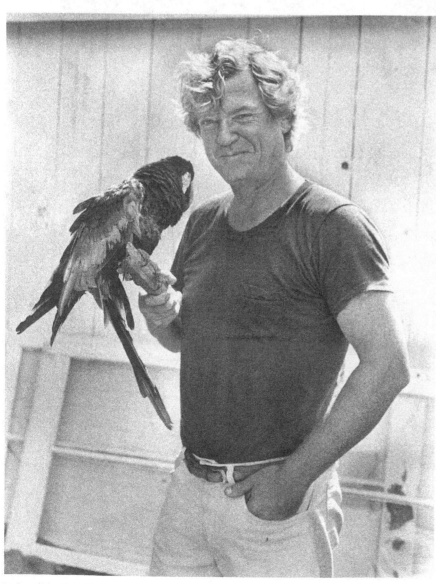

Robert Hughes, *Shelter Island, New York*, 1983

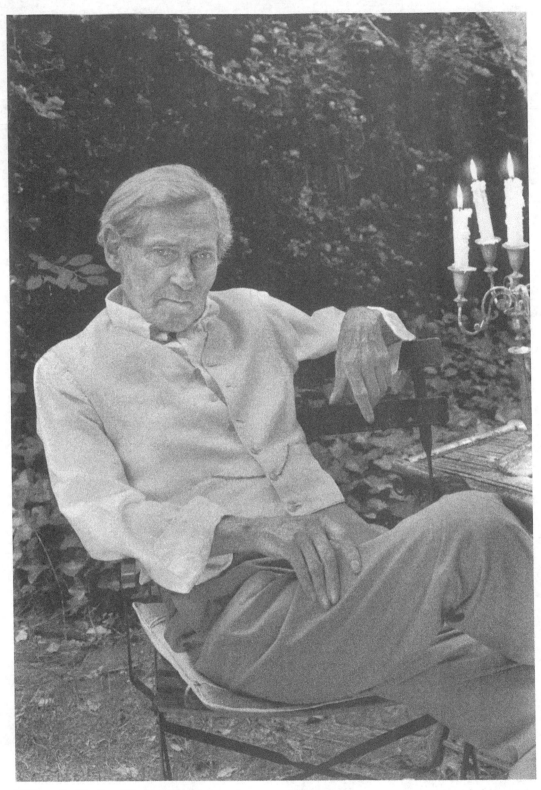

William Gaddis, *East Hampton, New York,* 1996

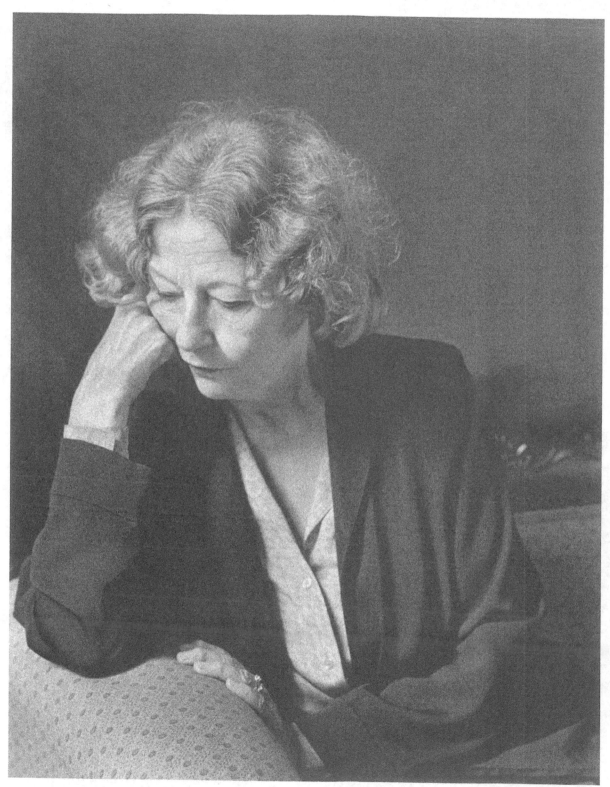

Elizabeth Hardwick, *New York City*, 1983

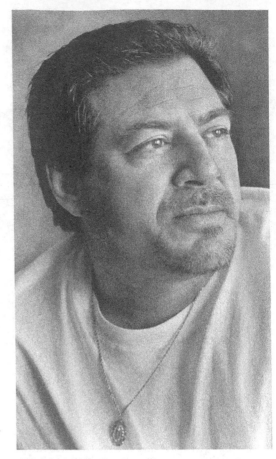

Dagoberto Gilb, *New York City*, 2000

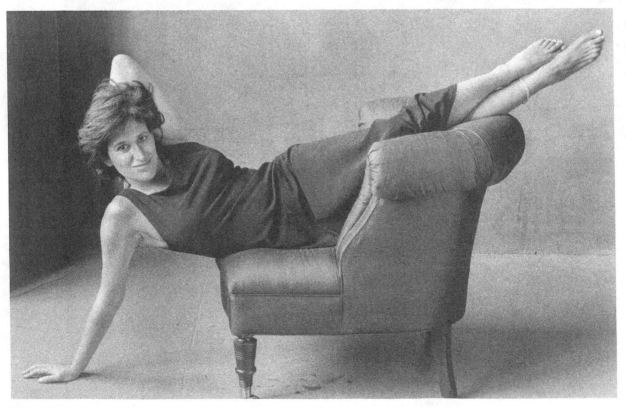

Melissa Bank, *New York City*, 1998

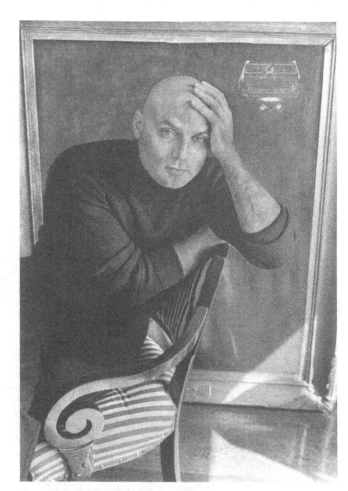

Daniel Mendelsohn, *New York City*, 1998

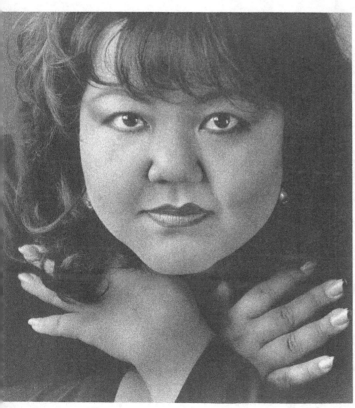

Lois-Ann Yamanaka, *New York City*, 1997

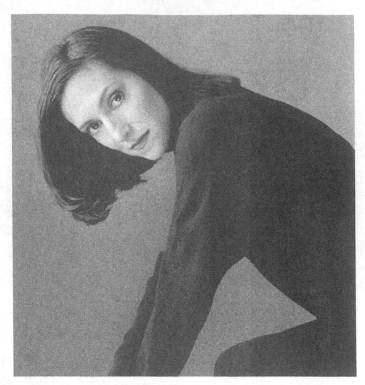

Fran Gordon, *New York City*, 1998

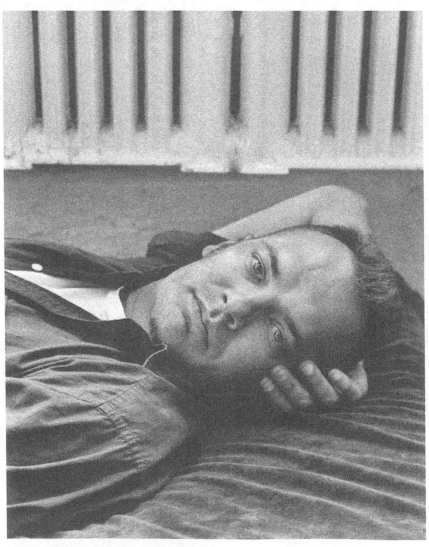

Andrew Huebner, *New York City*, 1999

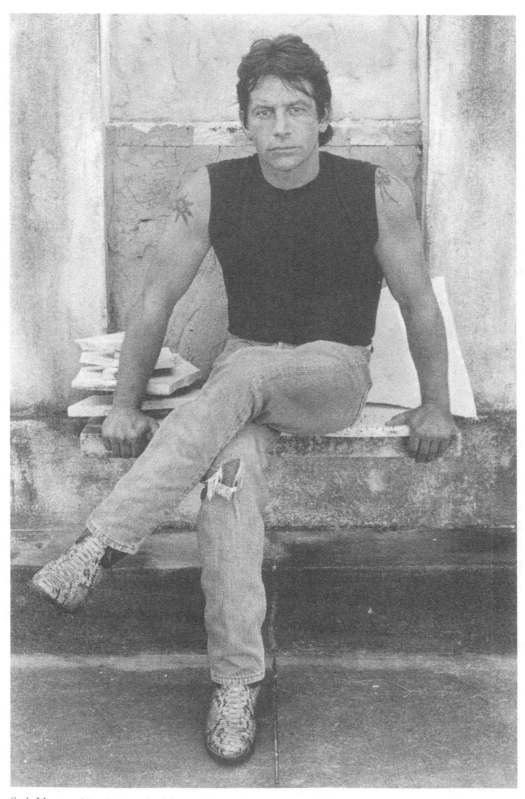

Seth Morgan, *New Orleans, Louisiana*, 1989

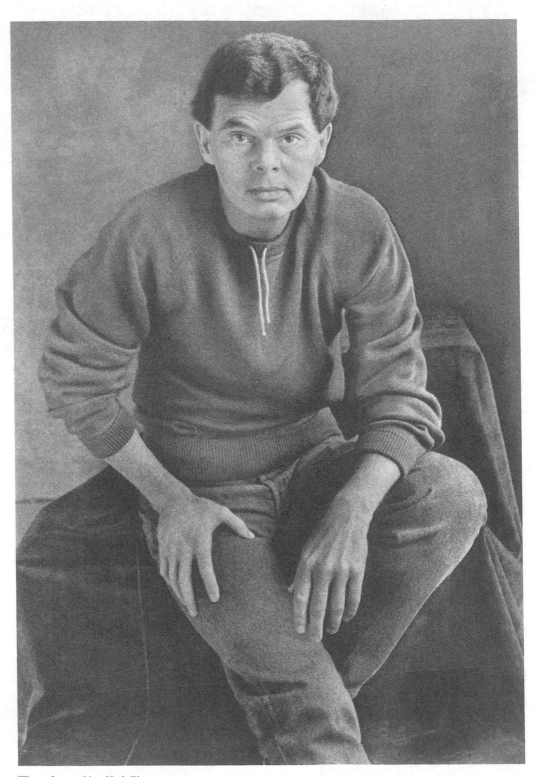

Thom Jones, *New York City*, 1993

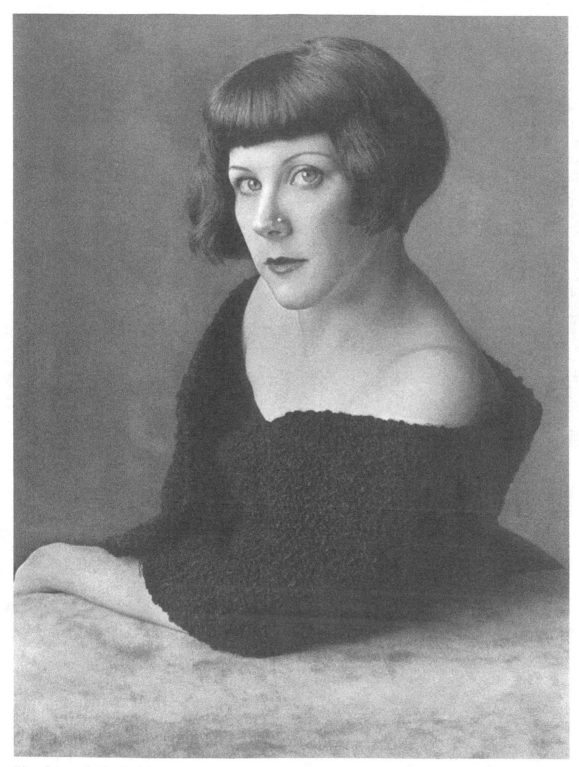

Elissa Schappell, *New York City*, 1999

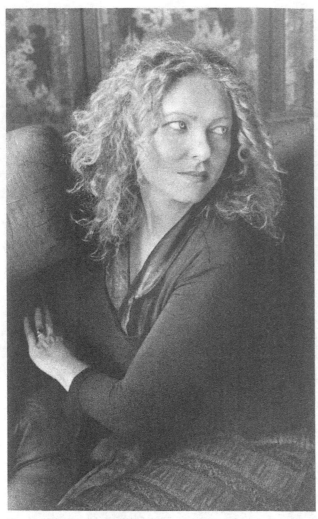

Karen McKinnon, *New York City,* 2001

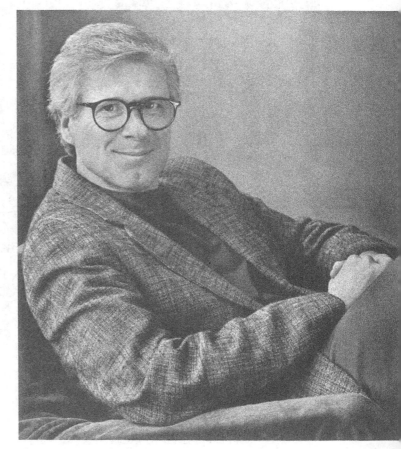

Thomas Mallon, *New York City,* 1996

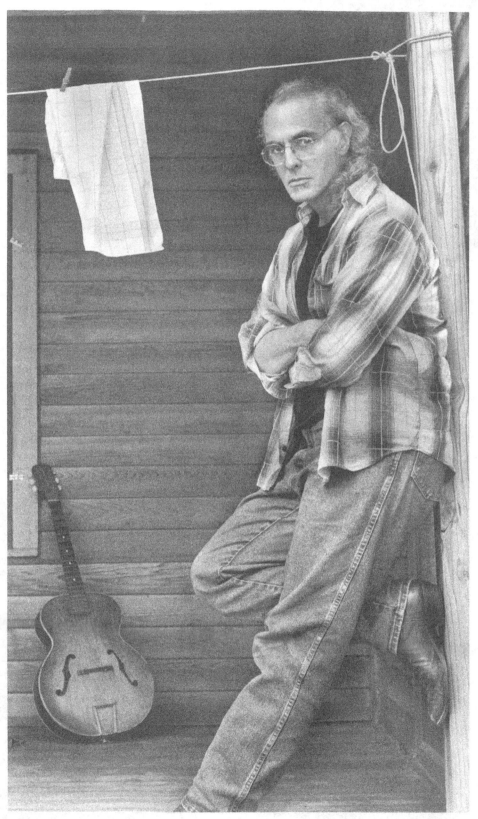

David Gates, *Granville, New York*, 2001

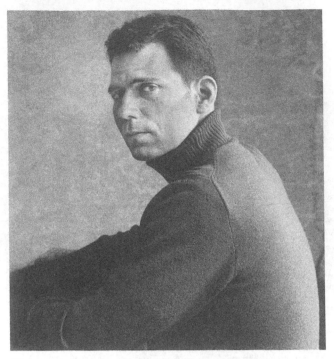

Christopher Sorrentino, *New York City*, 2002

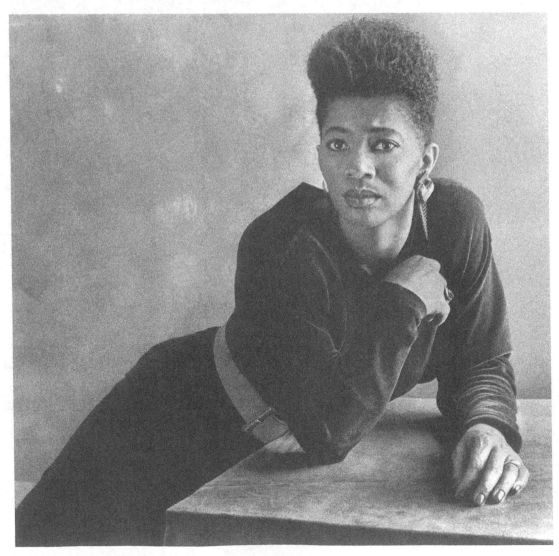

Terry McMillan, *New York City*, 1992

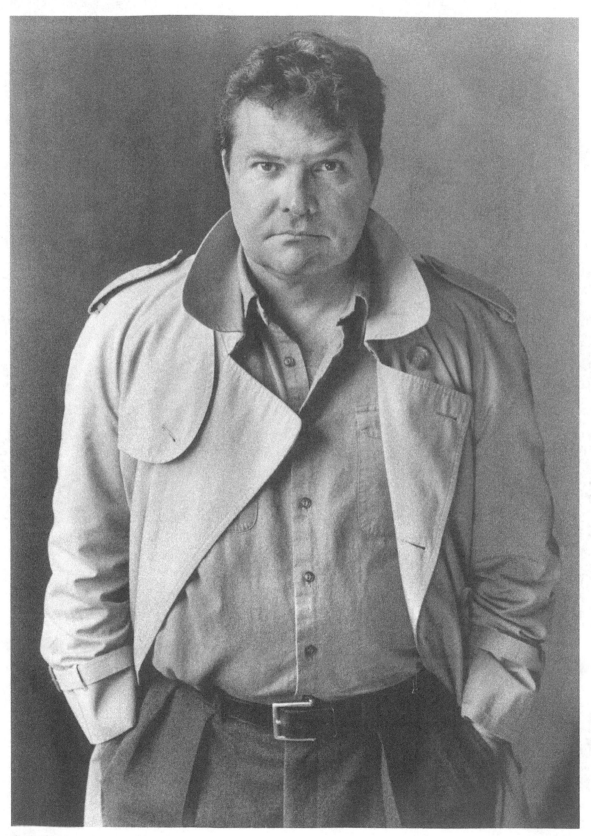

Denis Johnson, *New York City,* 2002

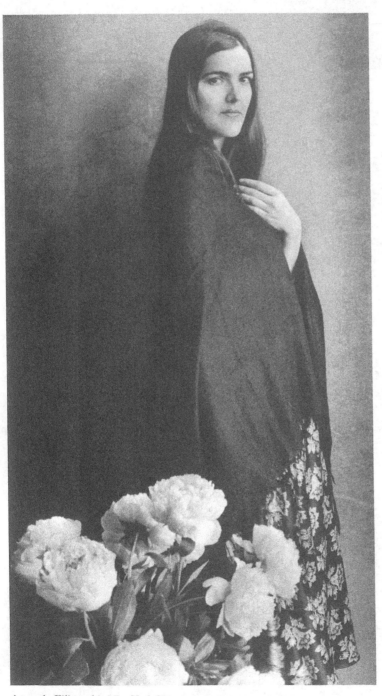

Amanda Filipacchi, *New York City*, 2001

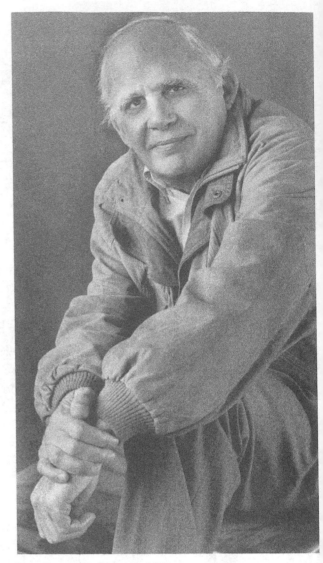

J. Anthony Lukas, *New York City*, 1997

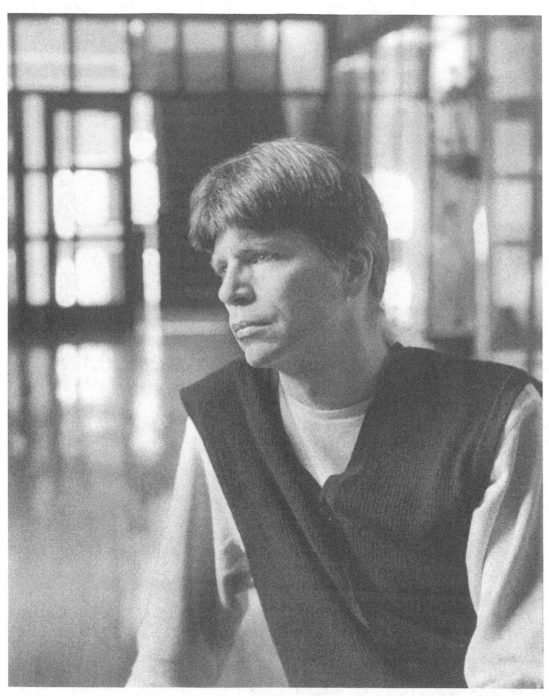

Richard Powers, *The Natural History Building, Urbana, Illinois,* 2001

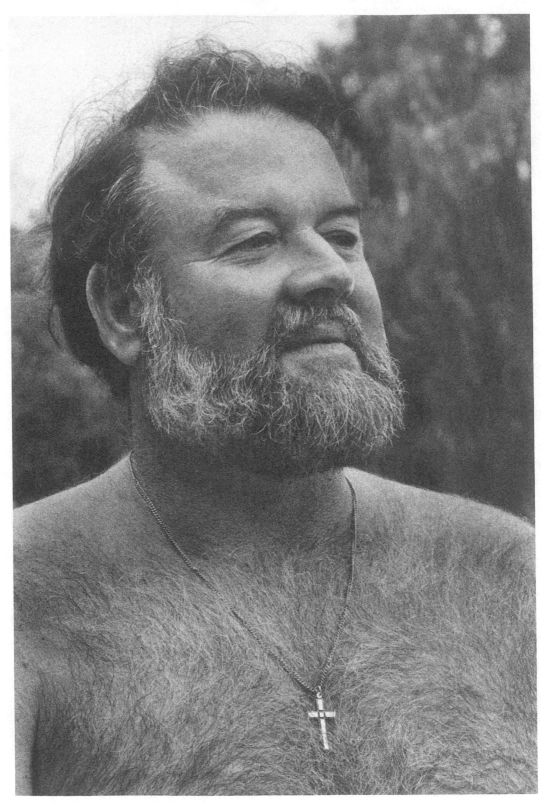

Andre Dubus, *Haverhill, Massachusetts,* 1988

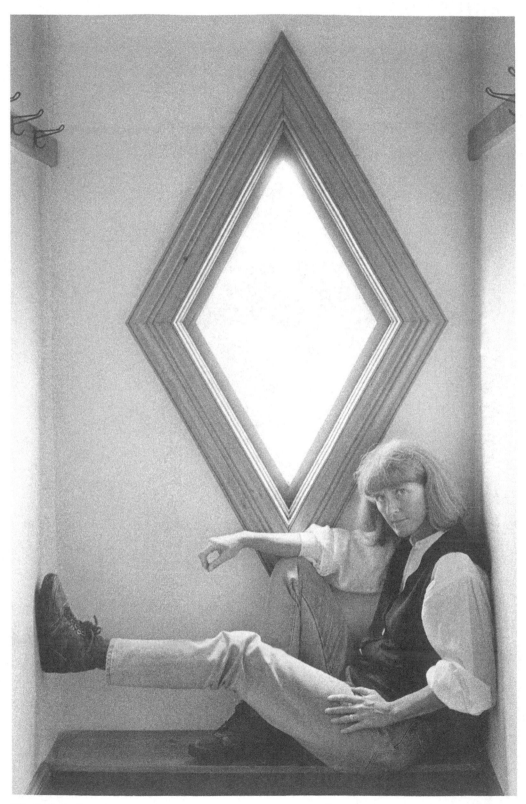

Elizabeth Arthur, *Bread Loaf, Ripton, Vermont*, 1994

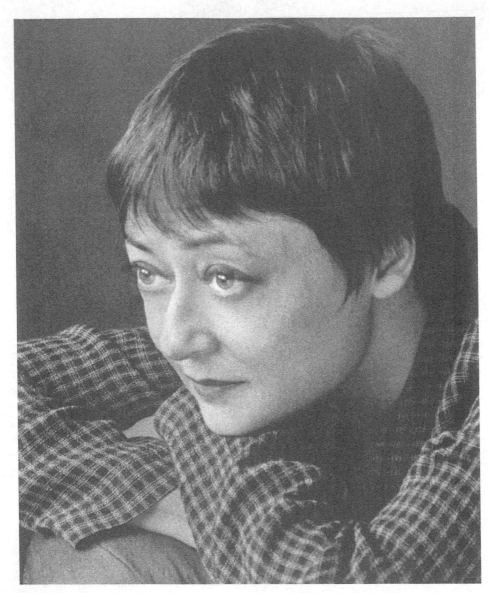

Sigrid Nunez, *New York City*, 1997

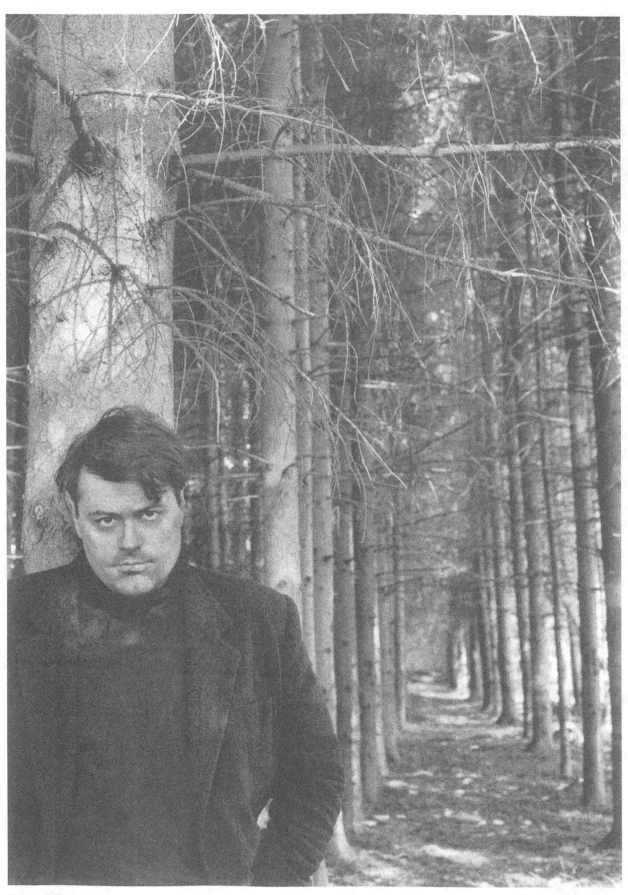

Robert O'Connor, *Liverpool, New York*, 1996

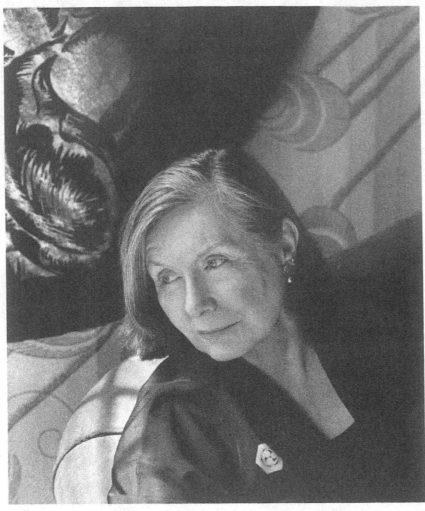

Maureen Howard, *New York City*, 1997

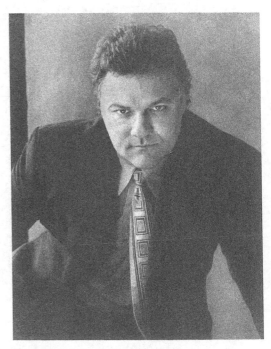

Craig Holden, *New York City*, 2001

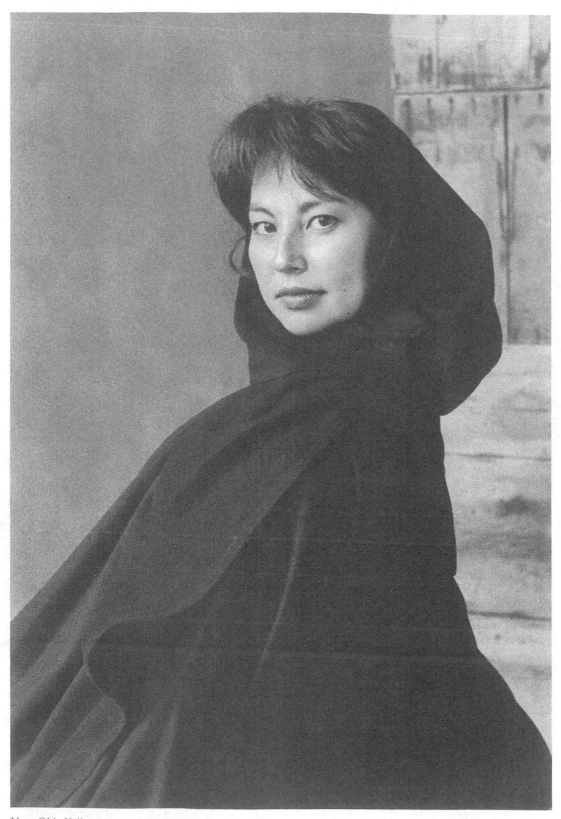

Nora Okja Keller, *New York City*, 1996

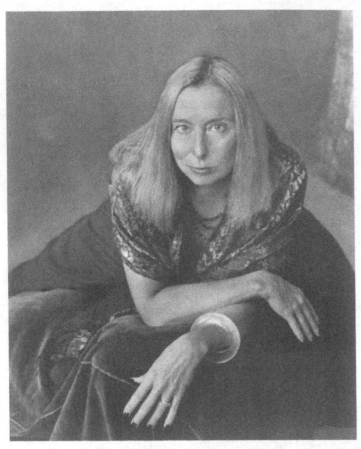

Ann Beattie, *New York City*, 1998

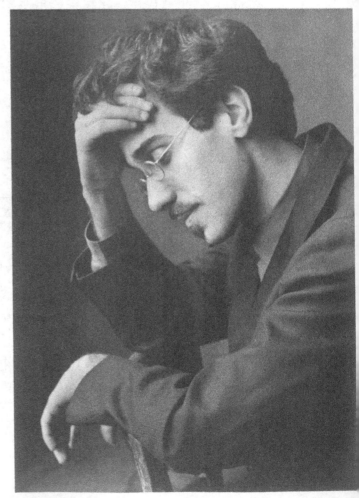

Paul La Farge, *New York City*, 1999

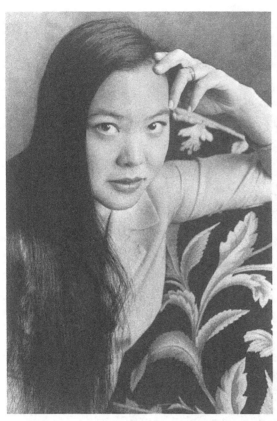

Monique Truong, *New York City*, 2002

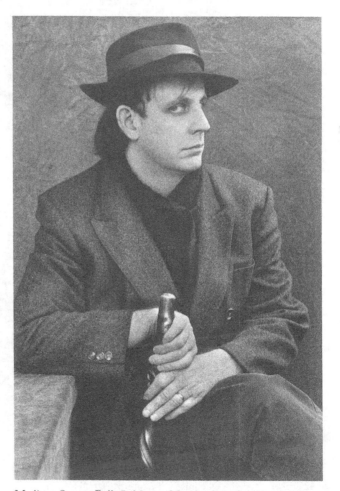

Madison Smartt Bell, *Baltimore, Maryland*, 1996

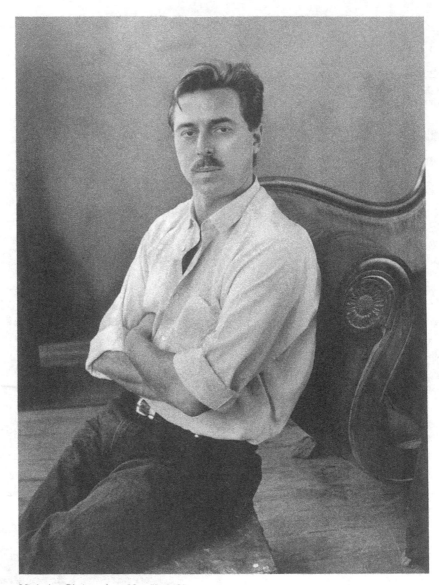

Nicholas Christopher, *New York City*, 1991

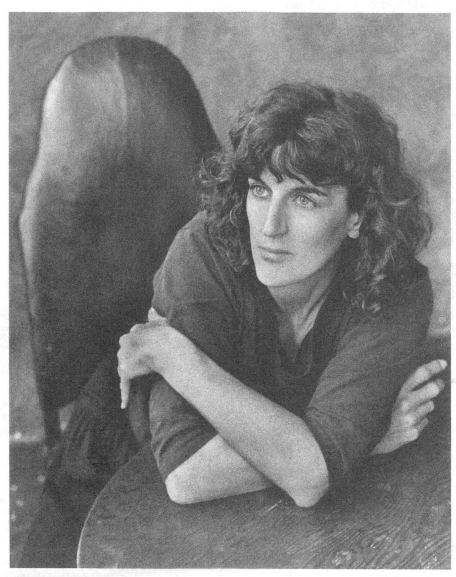

Kathryn Davis, *New York City*, 1992

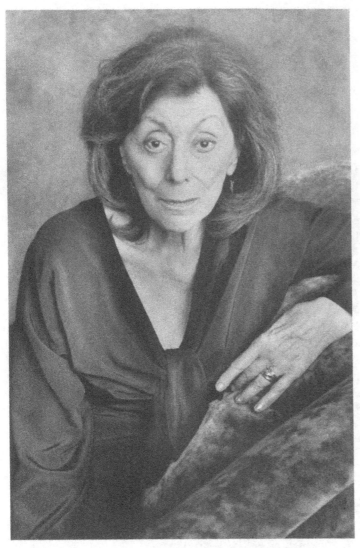

Hortense Calisher, *New York City*, 2001

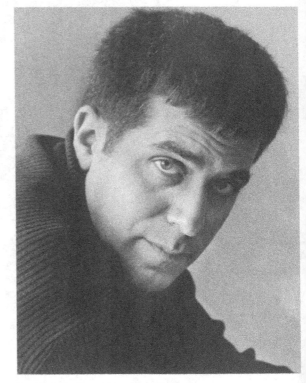

Jonathan Lethem, *New York City*, 2001

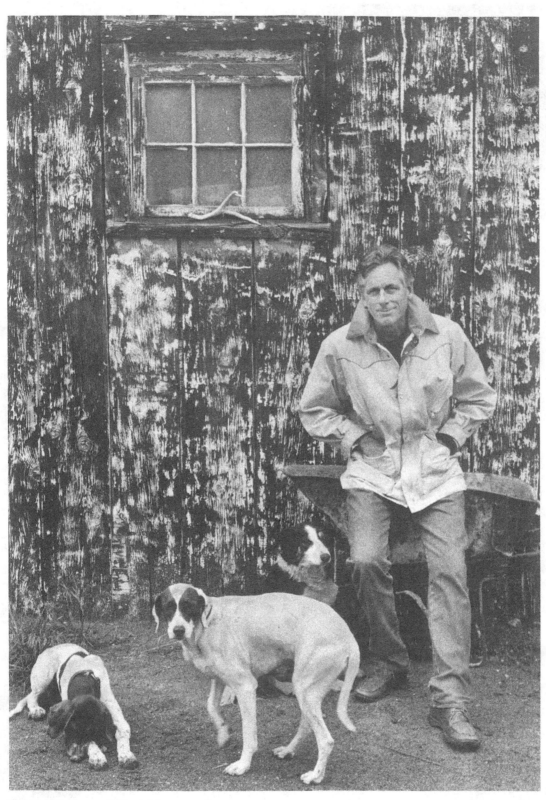

Thomas McGuane, *McLeod, Montana*, 1989

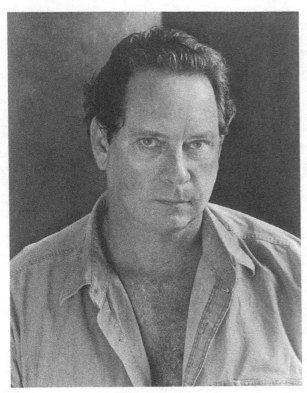

Padgett Powell, *New York City*, 1997

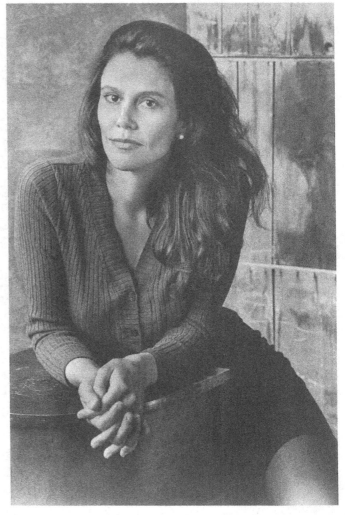

Isabel Fonseca, *New York City*, 1995

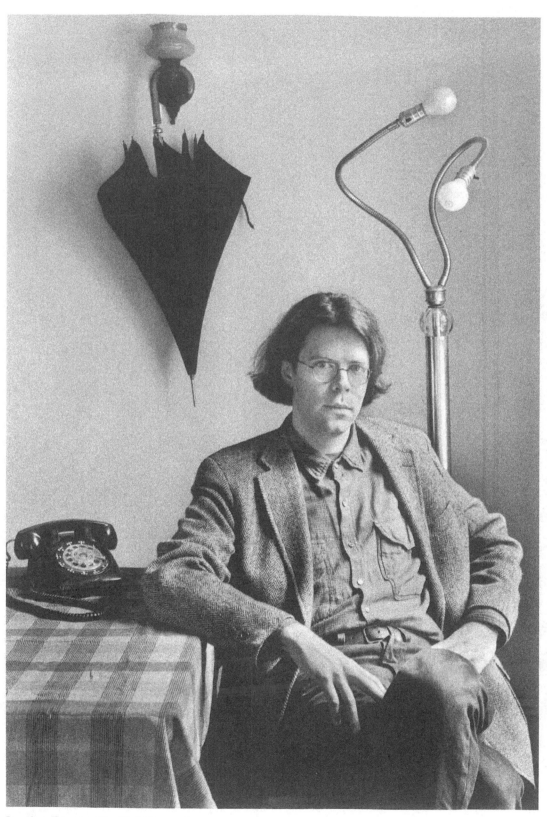

Jonathan Franzen, *New York City*, 1996

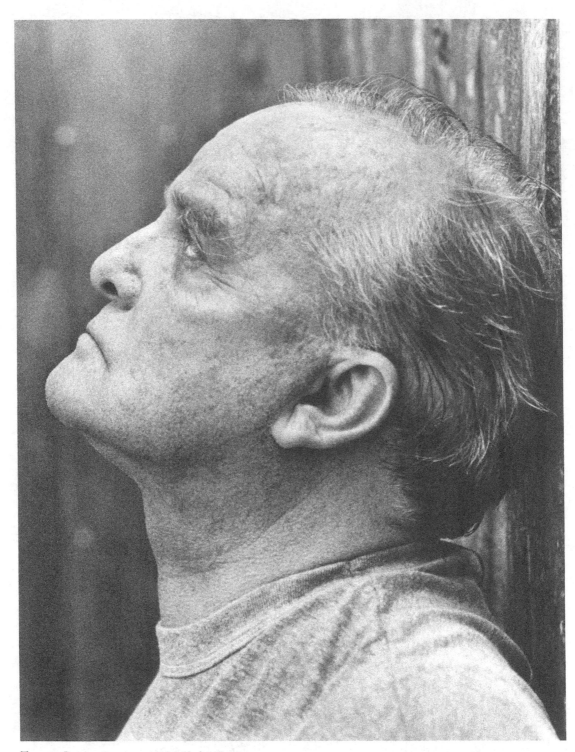

Truman Capote, *Sagaponack, New York*, 1983

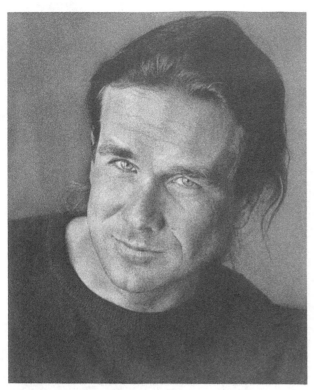

Tom Paine, *New York City*, 1999

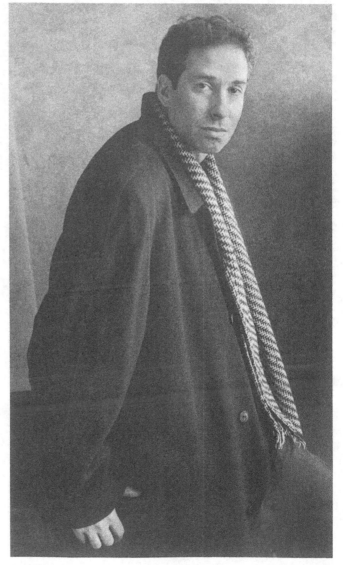

James Lasdun, *New York City*, 2001

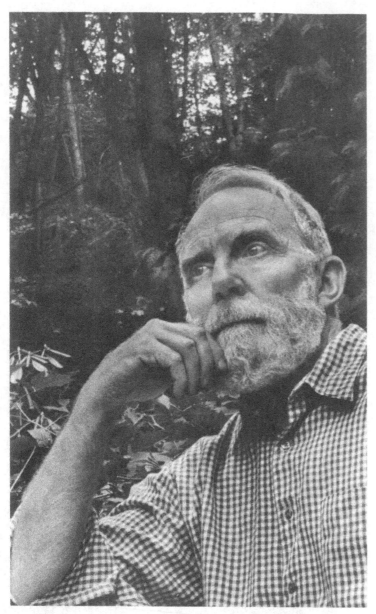

Ivan Doig, *Seattle, Washington,* 1997

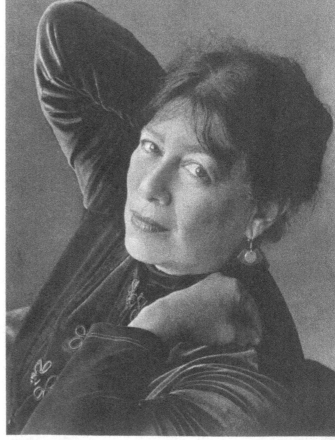

Rosellen Brown, *New York City,* 2000

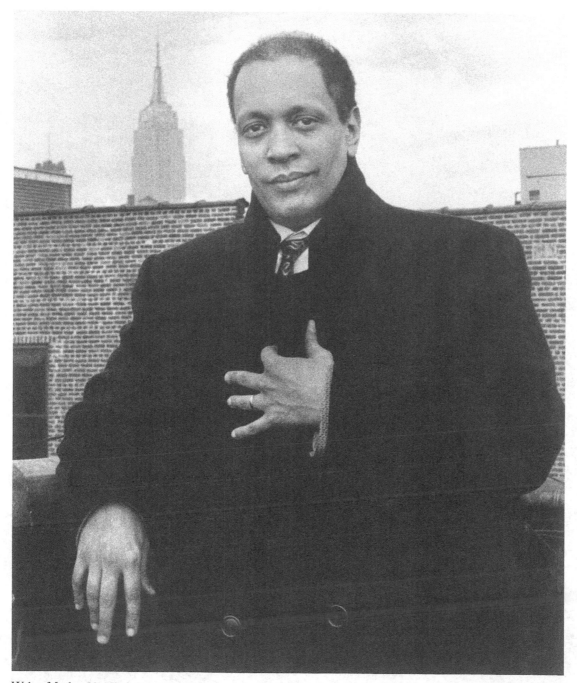

Walter Mosley, *New York City*, 1990

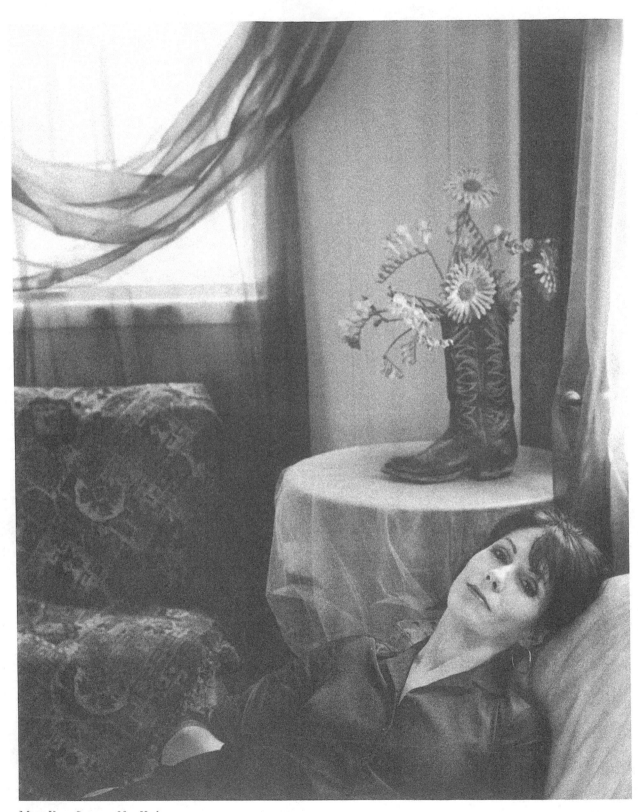

Mary Karr, *Syracuse, New York*, 2001

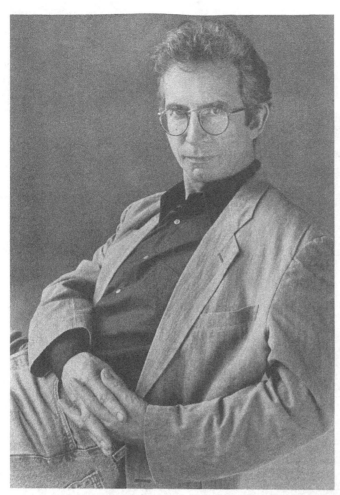

Peter Carey, *New York City,* 1997

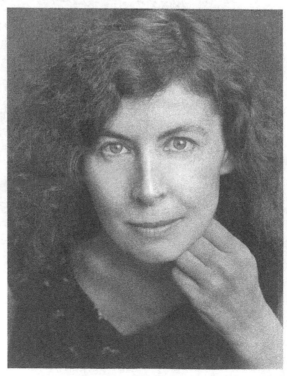

Margot Livesy, *New York City,* 1995

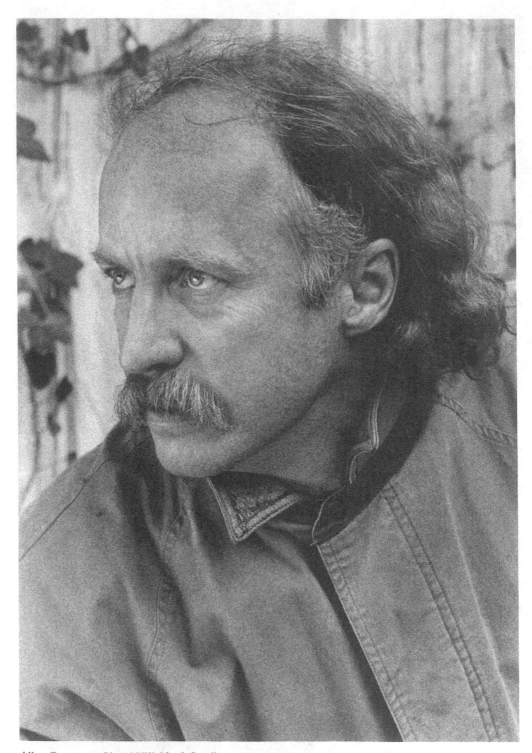

Allan Gurganus, *Chapel Hill, North Carolina*, 1990

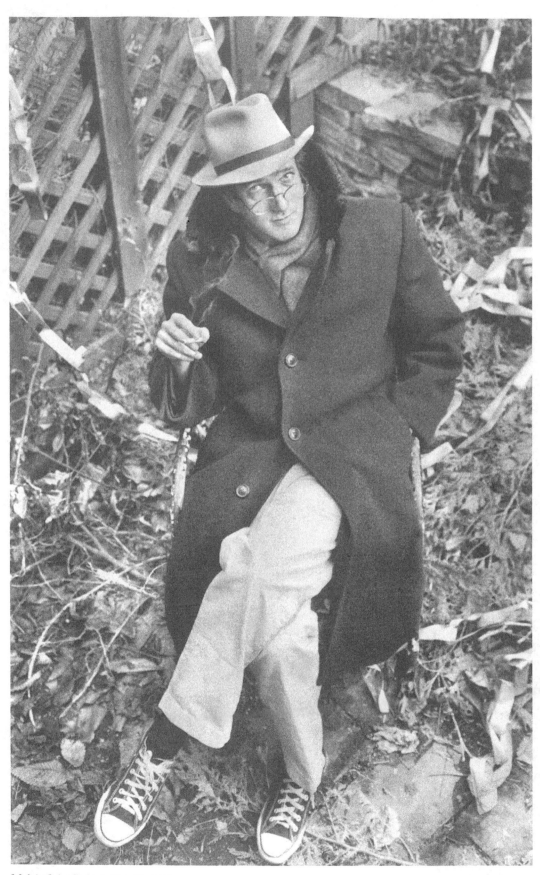

Melvin Jules Bukiet, *New York City*, 2002

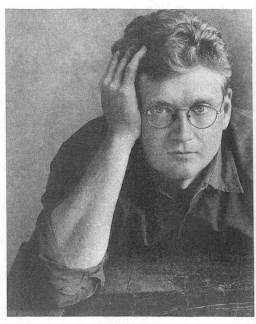

Jonathan Dee, *New York City*, 2001

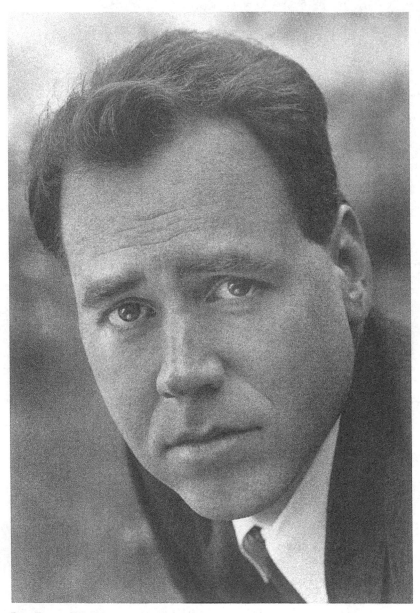

Bret Easton Ellis, *Amagansett, New York*, 1994

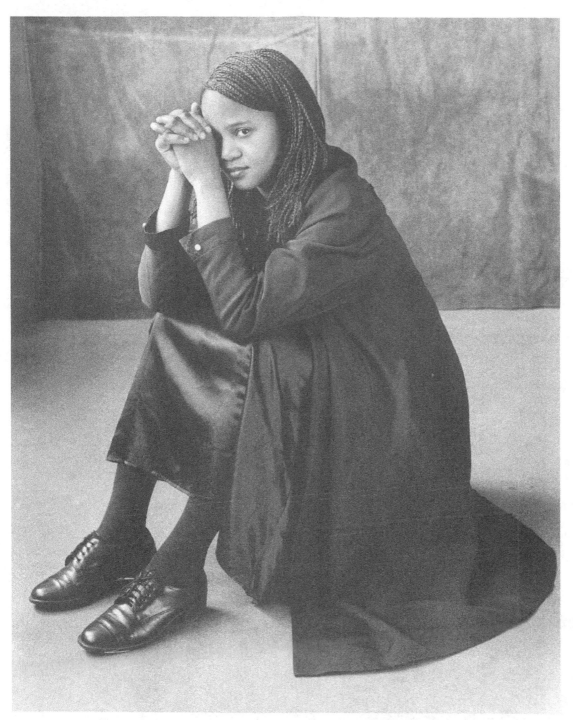

Edwidge Danticat, *New York City,* 1996

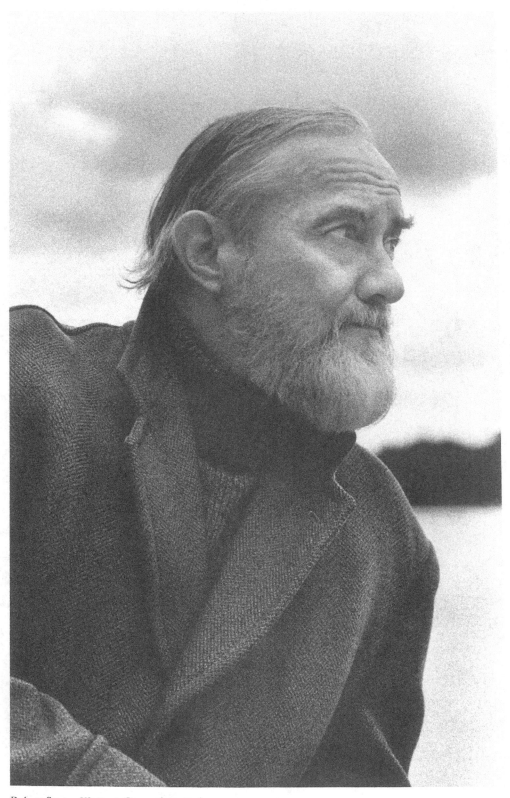

Robert Stone, *Westport, Connecticut,* 1996

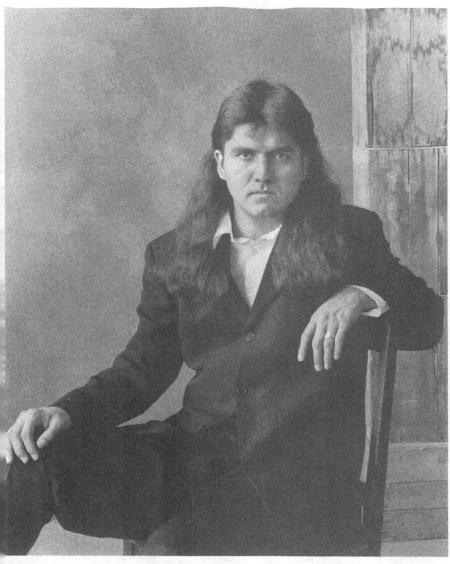

Sherman Alexie, *New York City*, 1996

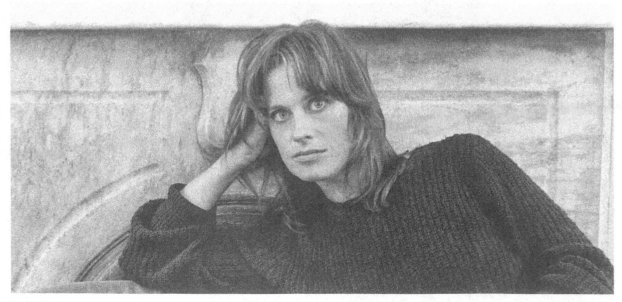

Lydia Davis, *Brooklyn, New York*, 1985

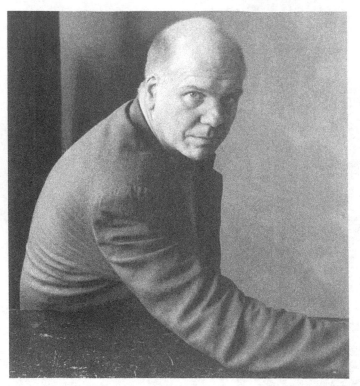

Peter Robinson, *New York City*, 2002

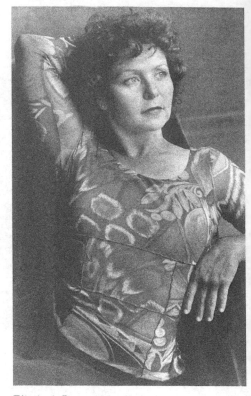

Elizabeth Rosner, *New York City*, 2002

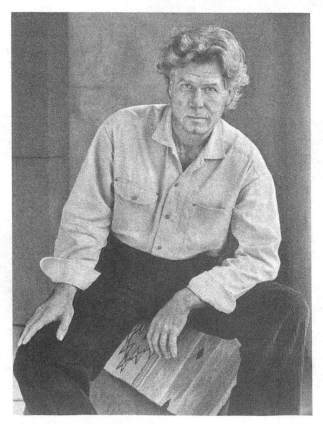

Bradford Morrow, *New York City*, 1994

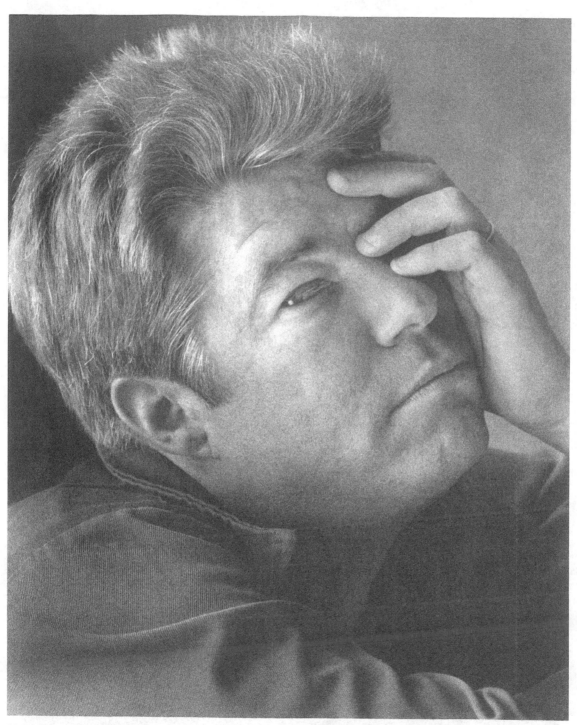

Chris Offutt, *New York City*, 1996

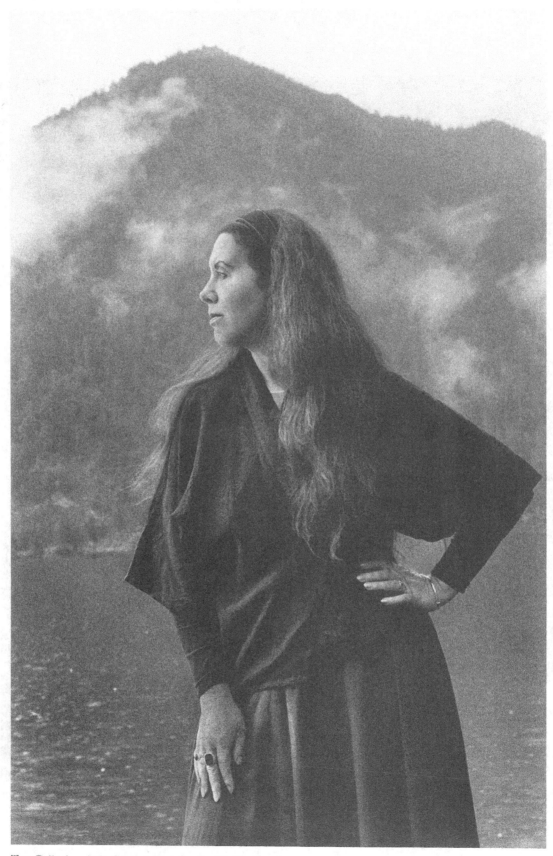

Tess Gallagher, *Lake Crescent, Port Angeles, Washington,* 1990

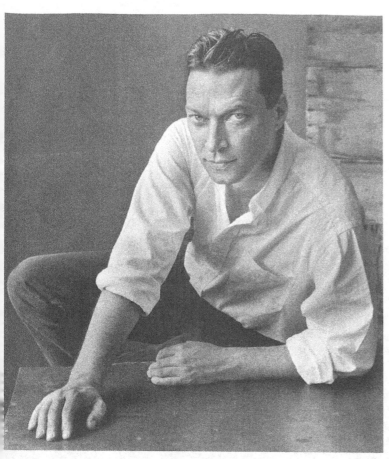

Scott Anderson, *New York City*, 1998

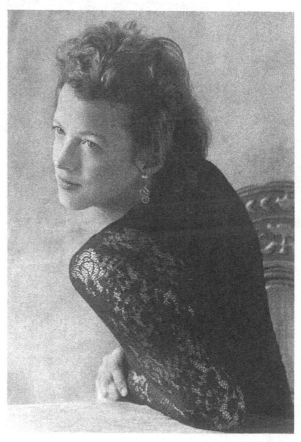

Kate Wheeler, *Somerville, Massachusetts*, 1996

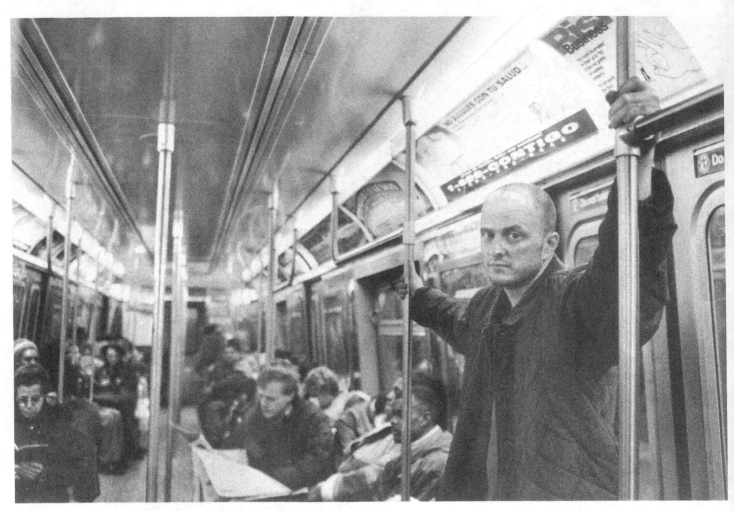

Jeffrey Eugenides, *D Train, Brooklyn, New York*, 1996

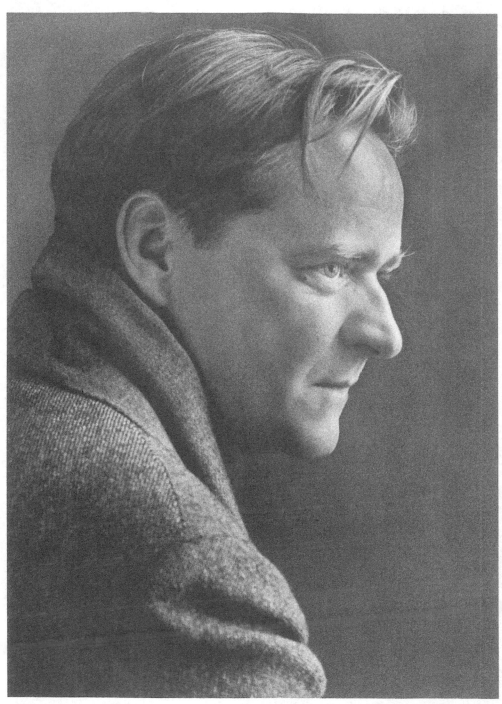

Paul Gervais, *New York City*, 1994

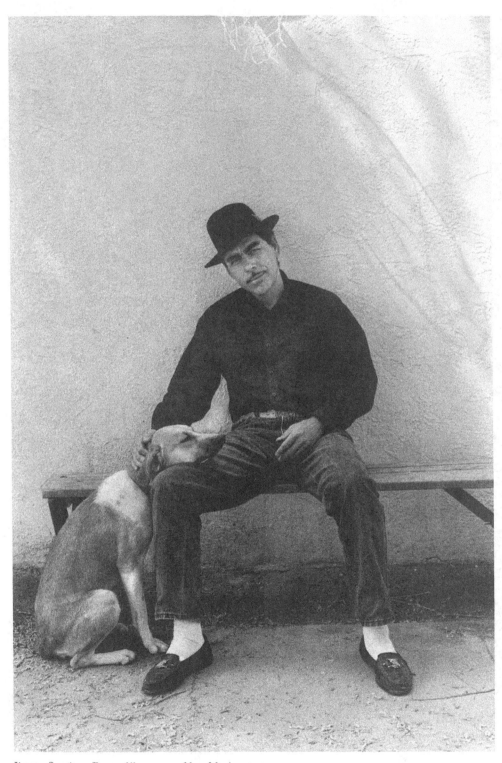

Jimmy Santiago Baca, *Albuquerque, New Mexico*, 1992

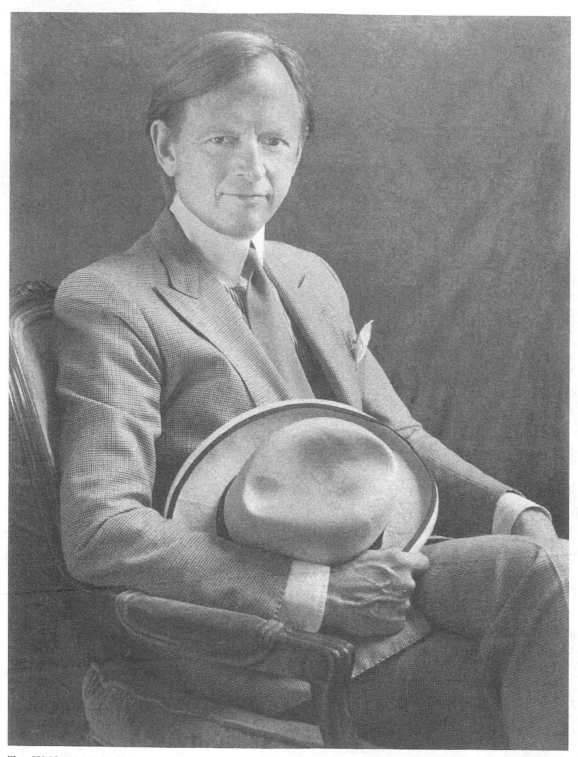

Tom Wolfe, *New York City,* 1983

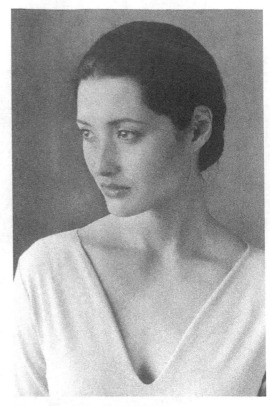

Charmaine Craig, *New York City*, 2001

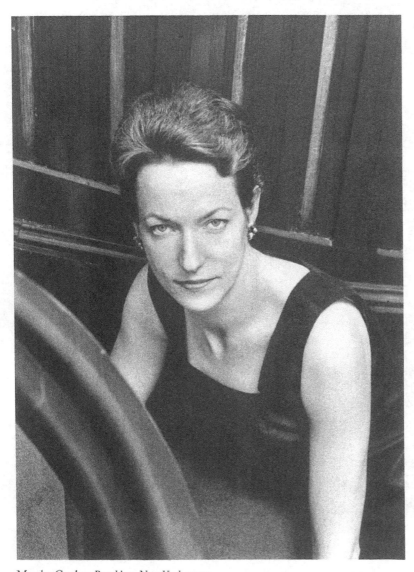

Martha Cooley, *Brooklyn, New York*, 2001

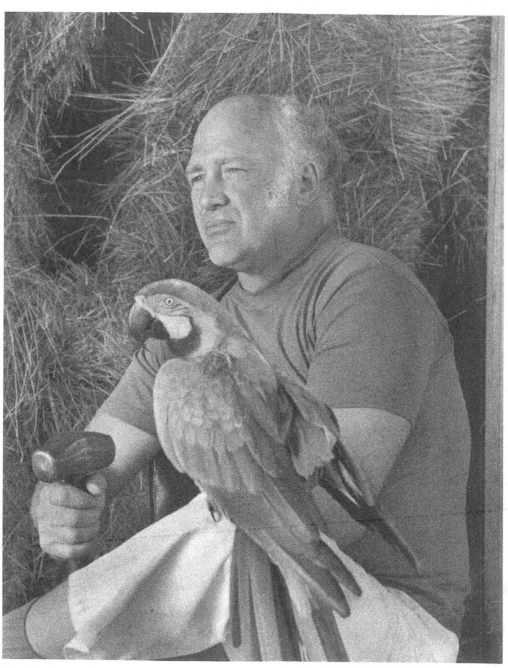

Ken Kesey, *Pleasant Hill, Oregon*, 1983

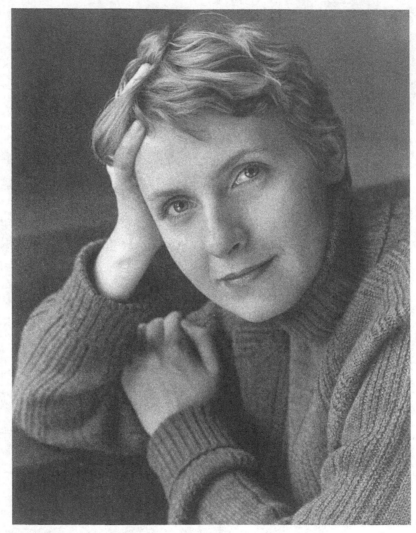

Elizabeth Gilbert, *New York City*, 1997

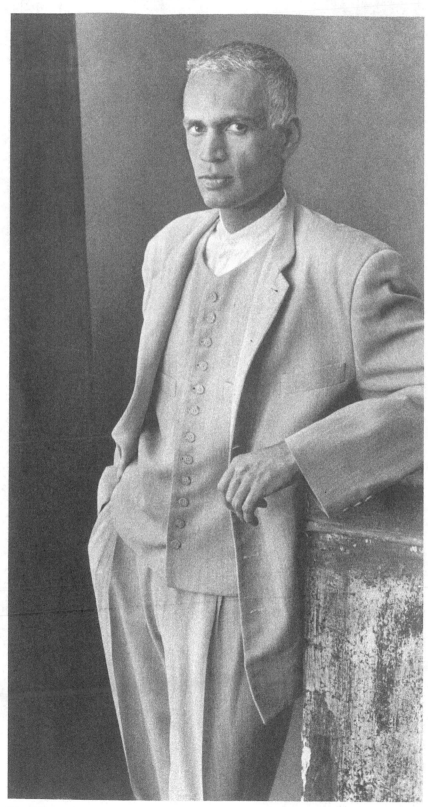

Manil Suri, *New York City*, 2000

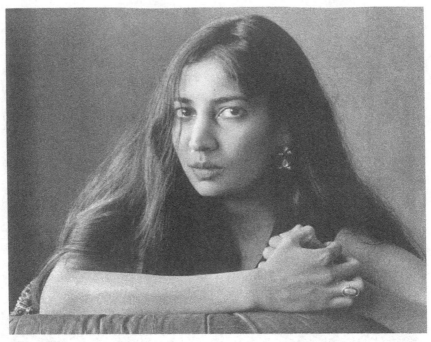

Kiran Desai, *New York City*, 1997

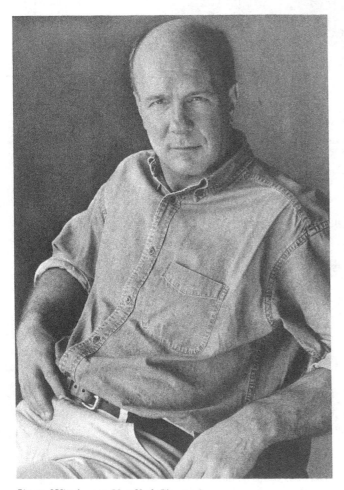

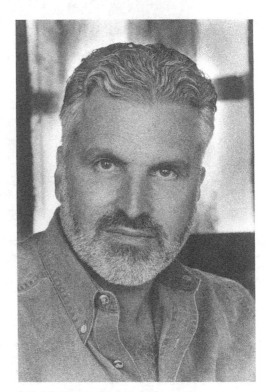

J. D. McClatchy, *New York City*, 1996

Simon Winchester, *New York City*, 1998

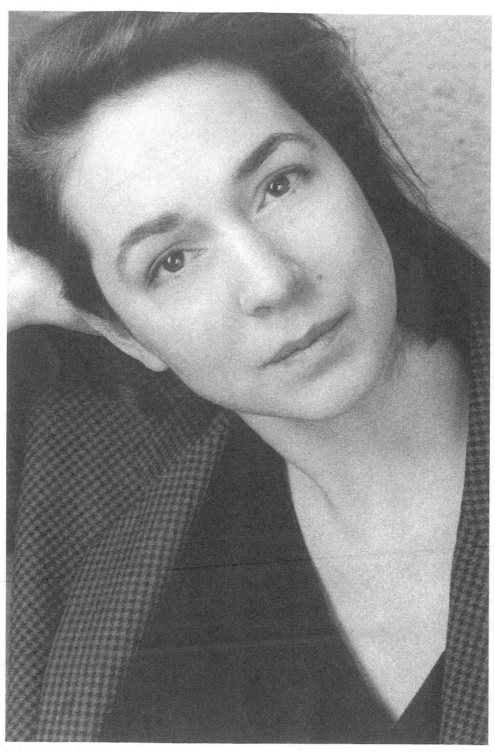

Lorrie Moore, *Madison, Wisconsin,* 1996

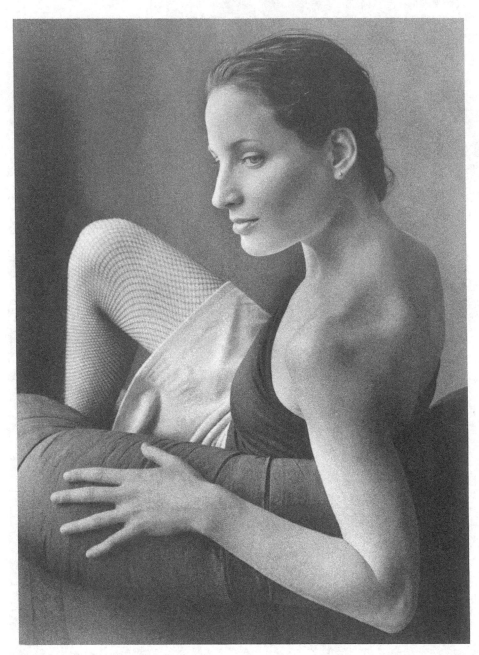

Lucinda Rosenfeld, *New York City*, 2000

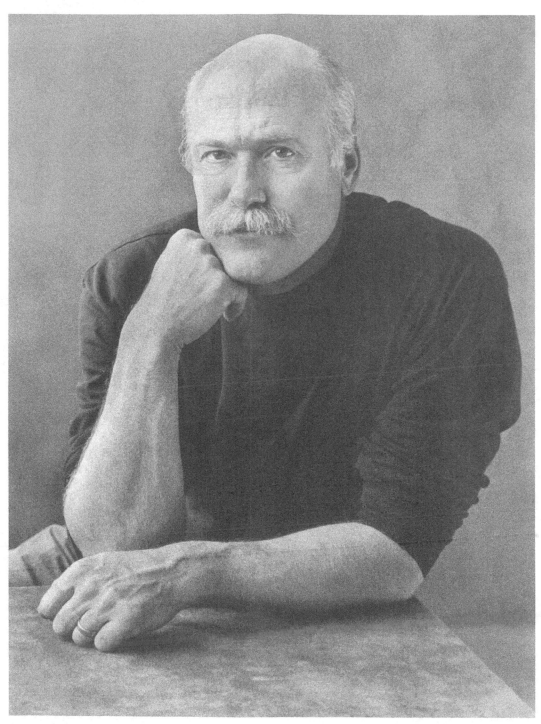

Tobias Wolff, *New York City*, 1995

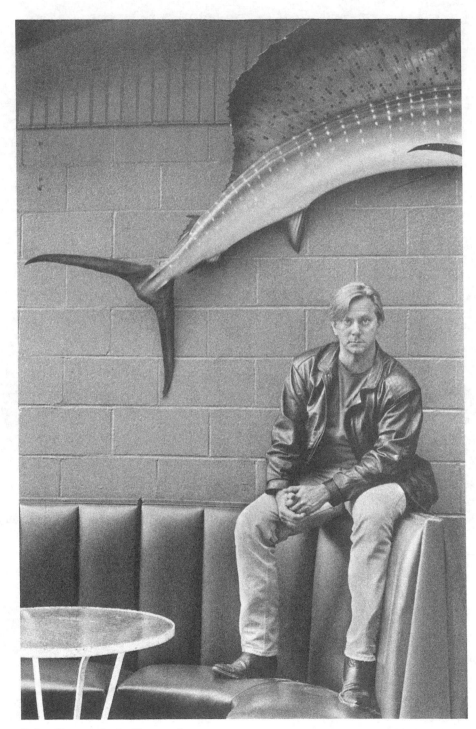

Robert Draper, *Austin, Texas,* 1998

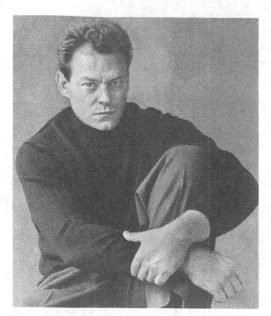

Daniel Silva, *New York City*, 1996

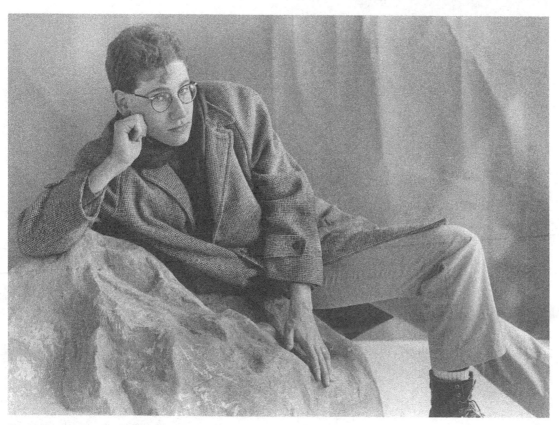

David Leavitt, *New York City*, 1985

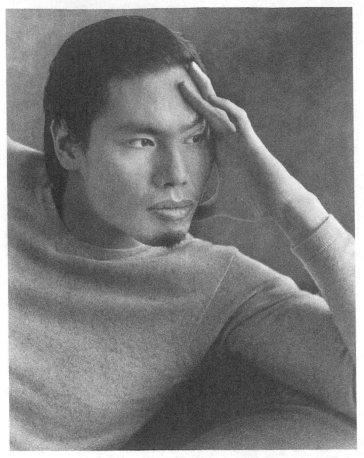

Han Ong, *New York City*, 2000

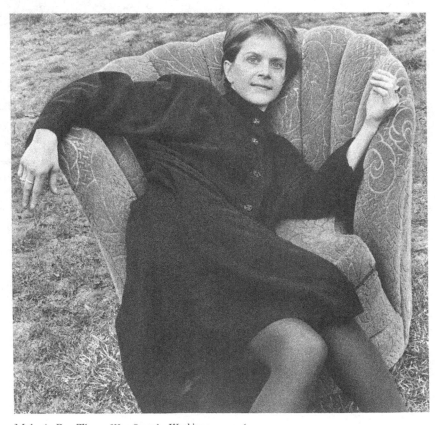

Melanie Rae Thon, *West Seattle, Washington*, 1996

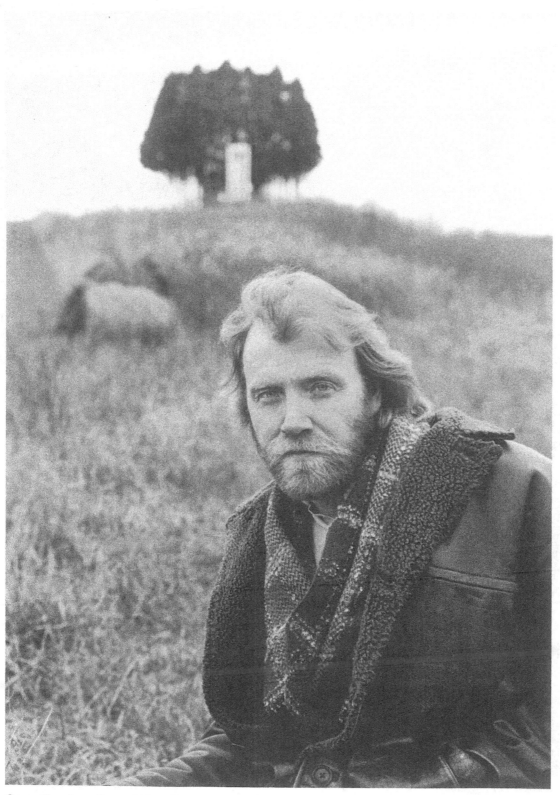

George Saunders, *Alverna Heights Convent, Manlius, New York,* 2001

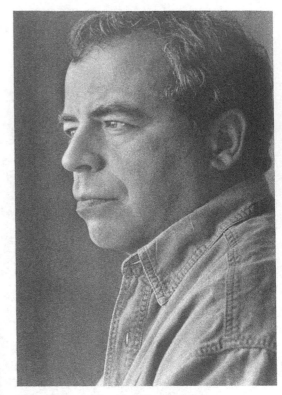

Richard Russo, *New York City*, 1996

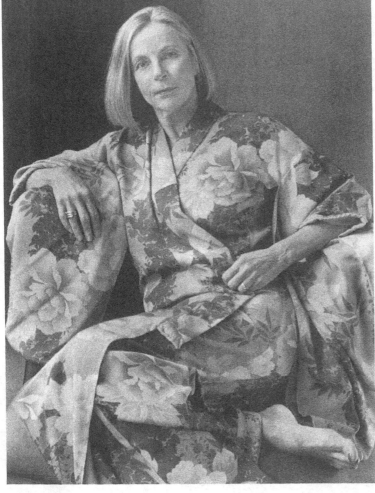

Lily Tuck, *New York City*, 1999

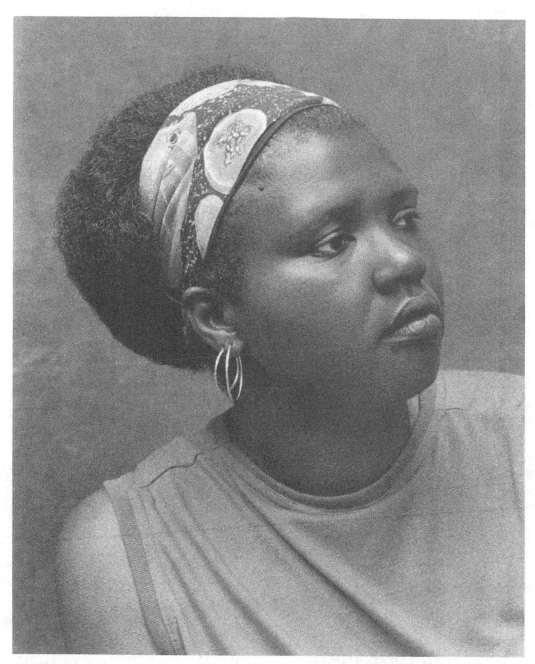

Gloria Naylor, *Brooklyn, New York*, 1993

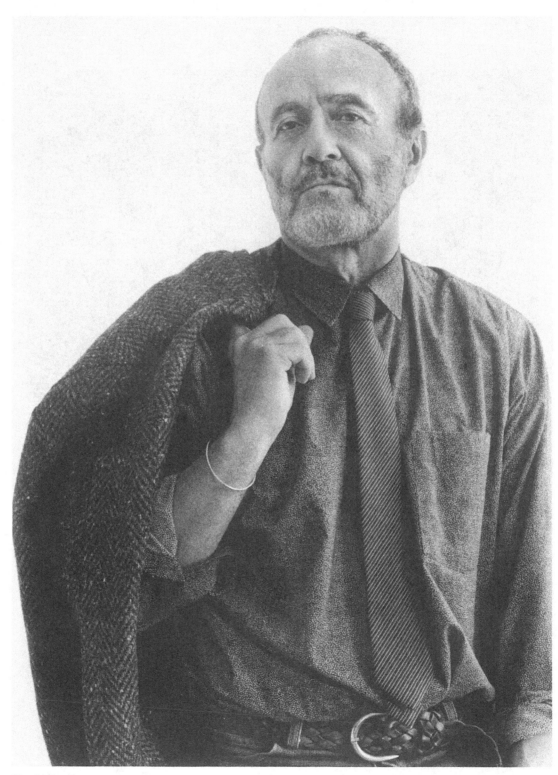

Harold Brodkey, *New York City*, 1985

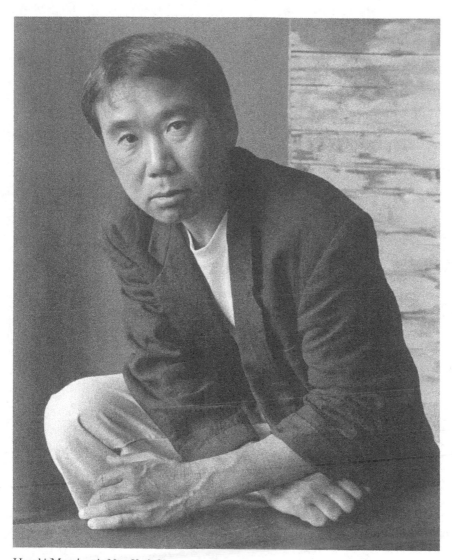

Haruki Murakami, *New York City*, 1997

ACKNOWLEDGMENTS

I am deeply grateful to:

Hans and Gertrude Ettlinger

Paul Aschenbach
Svetlana Dalski
Henry Dunow
Richard Ford
Chip Kidd
Arnold Newman
Sam Potts
Robert Priest
David Rosenthal
Denise Roy

and David Friedman

SIMON & SCHUSTER
Rockefeller Center
1230 Avenue of the Americas
New York, NY 10020

For information regarding special discounts for bulk purchases,
please contact Simon & Schuster Special Sales at
1-800-456-6798 or business@simonandschuster.com

DESIGNED BY SAM POTTS INC.

1 3 5 7 9 10 8 6 4 2

Library of Congress Cataloging-in-Publication Data
Ettlinger, Marion
Author photo : portraits, 1983–2002 / Marion Ettlinger ;
foreword by Richard Ford.
p. cm.
1. Authors—Portraits. 2. Portrait photography.
3. Ettlinger, Marion. I. Title.
TR681.A85E88 2003
779'.6809—dc21
2003045423

ISBN 978-1-4516-5615-2